The Return of the Brown Pelican

The Return of the Brown Pelican

Photographs by Dan Guravich

Text by Joseph E. Brown

LOUISIANA STATE UNIVERSITY PRESS
BATON ROUGE AND LONDON

Copyright © 1983 by Louisiana State University Press
All rights reserved
Manufactured in the United States of America
Design: Joanna Hill
Typeface: Linotron Primer
Composition: G&S Typesetters, Inc.
Printer: Dai Nippon Printing Company
 and Hart Graphics
Binder: Kingsport Press

LIBRARY OF CONGRESS CATALOGING IN PUBLICATION DATA

Guravich, Dan.
 The return of the brown pelican.

 Includes index.
 1. Brown pelican. I. Brown, Joseph E., 1929–
II. Title.
QL696.P47G87 1983 598.4′3 83-901
ISBN 0-8071-1114-7

Contents

Foreword

by Roger Tory Peterson

Audubon's dramatic portrait of a male brown pelican in the mangroves would bring upwards of five thousand dollars today on the auction block. Five thousand dollars for a single print. The original watercolor, hanging in the galleries of the New York Historical Society, would be beyond price.

But to paint this portrait, and the one he drew later of a young bird, Audubon did not need as many pelicans as he shot. He could not resist a flying target. He wrote: "I procured specimens at different places, but nowhere as many as at Key West. There you would see them flying within pistol shot of the wharfs, the boys frequently knocking them down with stones." He noted that "within the recollection of people still living, its numbers have been considerably reduced, so much indeed that in the inner bay of Charleston, where twenty or thirty years ago it was quite abundant, very few individuals are now seen." He added that they were "year after year retiring from the vicinity of man, and although they afford very unsavory food at any period of their lives, will yet be hunted beyond the range of civilization until to meet with them the student of nature will have to sail around Tierra del Fuego."

Audubon's pessimistic prediction did not come true, thanks to the national organization which bears his name and also to the efforts of our federal government. At the turn of the century it was feared that pelicans, like egrets, and some terns, were on the way out; but the decline was reversed when Theodore Roosevelt, in 1903, initiated the federal refuge system by setting aside an island on the east coast of Florida specifically for brown pelicans.

Today, when a pelican appears on a Florida dock, people throw fish,

not rocks. Attitudes have changed dramatically. These seriocomic birds with their accordian pleated pouches are the delight of every tourist who visits the beaches of Florida and California. The most popular pelicans of all are perhaps those that make the piers around Tampa and St. Petersburg their headquarters, patiently sitting on their posts until someone offers a handout. At Venice, Florida, I once watched a juvenile pelican walk into a fish market, and stand expectantly before the counter until the proprietor gave it a fish and saw it out the door.

At once profoundly dignified, as birds of ancient lineage should be, pelicans are at the same time masters of deadpan clowning (so it seems to me), especially when two or three birds contend for the same fish. Some of these pelicans that prefer begging to an honest livelihood, nest with multitudes of their wilder brethren on the mangrove islands well out in Tampa Bay. Many are accidentally hooked or become tangled in the monofilament lines of fishermen and become critically injured. These unhappy individuals are rounded up by the Suncoast Seabird Sanctuary in St. Petersburg where hundreds of pelicans are rehabilitated yearly. The story of this humanitarian work by Ralph Heath and his coworkers is related in the following pages.

Forces more decimating than the hooks of fishermen, and far more subtle, have threatened pelican populations from time to time; environmental changes brought about by the burgeoning pressures of civilization. During the late forties and in the fifties calamity struck from an unexpected source. Toxic poisons in the food chain, presumably from contaminants pouring from the Mississippi, and other rivers, into the Gulf of Mexico, completely wiped out the last pelicans in Louisiana by 1961. Ironically, the pelican is the state bird of Louisiana, emblazoned on its shield. The neighboring state of Texas, where a few years earlier I had photographed thriving colonies in the Laguna Madre, also lost nearly all of its pelicans. Later a similar scourge hit the breeding pelicans of California. Only Florida was spared the holocaust. The chlorinated hydrocarbon, DDT, was found to be the prime culprit, but other less obvious chemical pollutants were also indicated.

I am old enough to have seen most of the prime colonies in their heyday. As a young man I visited nearly all of them—the Coronados just south of San Diego, the Texas colonies in the Laguna Madre, as well as those in Florida and South Carolina. I witnessed the collapse of those in Louisiana, Texas, and California, but, thank heaven, the tide has turned.

Because nature is not an edifice, but a process, we can seldom put a piece of it into repair by simple action. However, only one thing is irreversible—the extinction of a species. Had we allowed the last brown pelican, the end product of millions of years of evolution, to slip away, no power on earth could bring it back.

The biologists' and the humanists' answer to the problem of saving the endangered brown pelican is meticulously elucidated in the following pages. In this absorbing story Joseph Brown gives us the details of one of the great conservation success efforts of our time. In addition, Dan Guravich, who loves pelicans as much as he loves polar bears, gives us a showcase of his superb wildlife photography.

The Return of the Brown Pelican

Introduction

Seeking a brief respite while this book was in its early stages of research, I provisioned my thirty-six-foot yawl *Gracie* one brisk spring morning and, with my wife, set a course for the Coronado Islands, twenty miles south of San Diego. The day was overcast, and neither the islands nor the mainland shoreline could be seen once we were a few miles from port. At the time, I was still somewhat of a tyro sailor; although *Gracie* had a fine new compass, it had not yet been "swung" for accuracy, and I could not vouch for its worth.

The Coronados, lying in Mexican territory, are easy to spot on a clear day from San Diego, but in a haze or fog many an inexperienced mariner is burdened with nagging fears that a gross error might send him wandering seaward of the islands; making a Coronados landfall can be a precarious business.

I was, in other words, sailing blind, unsure of my course, especially since I had not sailed to the Coronados before in my own boat. On several natural history cruises there, however, I had become enchanted with these three small spits of rock wisely preserved by the Mexican government and designated a wildlife sanctuary. Diving is permitted, for instance, but no fish can be taken; landing on the islands themselves is prohibited without a special permit. In the spring, one of the islands is a prime nesting ground for the California brown pelican. From research and field trips, I knew that mature brown pelicans, nesting on high ledges of the islands, range as far as San Diego to find fish for their nesting young.

For two and a half hours, I fidgeted nervously, waiting to see my island landfall. Was I off course? Had some tricky offshore current somehow swung *Gracie* away from her tiny target?

Suddenly my worries were resolved. Just off the port bow, not one hundred feet away, a flock of perhaps twenty pelicans made their appearance, winging gracefully past us on a parallel course.

My relief was profound. "No need to worry," I told my wife, "we're exactly on course. Those pelicans are better than any man-made compass; they can't be going *anyplace* but their nesting site." Almost as I spoke, as I watched the V-flight of birds disappear into the haze ahead, one of the Coronados loomed out of the overcast. The birds had guided us directly to our destination.

It is not difficult to laugh at the pelican, certainly one of the most extraordinarily comical, grostesque, perhaps even ugly, members of the animal kingdom. Yet beauty does lie in the eye of the beholder, and though I chuckle as others do at the pelican's awkwardness and clumsiness—until he flies, that is—I also regard him with a feeling of sheer wonder.

Fossil remains indicate that the first pelicans existed some thirty or forty million years ago, meaning that a creature not much different from my winged compasses was around at the time when the first bird took flight on earth. That fossil represents the earliest evidence that the pelican has always been associated with the sea from which all life evolved. Since the first bird evolved from reptilelike land animals millions of years ago, nature has experimented with and then discarded all but about 9,000 of a total of 2,000,000 species of birds, the 9,000 representing the total ongoing speciation on earth today. A bird that has managed to survive this tremendous weeding-out process through the centuries, despite the onslaught of many inhibiting factors, including man, deserves a very special niche in the world of birds. I hope that this book will in some small measure stir new interest in the marvelously adapted brown pelican, a bird whose behavior has intrigued and impressed man since prehistoric times.

Despite its demonstrated capability for survival, the brown pelican can hardly be viewed as indestructible. The bird is officially endangered. Its name has been for some years on the endangered species list maintained by the United States Department of the Interior. No longer do ornithologists, tramping the coast of Louisiana, the marshy mangrove swamps of Florida, or the rocky offshore islands of California and Mexico, enumerate brown pelican populations in terms of thousands, as no less an authority than John James Audubon once described them, but in only hundreds or dozens or, in some areas, only a few scattered pairs.

In the early 1960s, there was alarming evidence that the brown pelican might disappear altogether, at least from the North American continent. Along the Louisiana coast, for instance, where old records indicated there were once 50,000 breeding pelicans and where the ornithologist H. C. Oberholser found 2,300 pelican nests on North Island in the Chandeleur chain in 1933, a count in 1961 found only 100 nests. In California the story was the same: hundreds of thousands of birds that had existed earlier in the same century now were greatly diminished. Except for a handful of brown pelicans in Galveston Bay, they had disappeared in Texas.

After considerable scientific investigation that lasted through the sixties, there was widespread agreement on a single cause for the decline, especially among the California pelican populations: DDT and related pesticides. In research project after research project, the evidence mounted: thinning of eggshells and organic damage caused by the birds' ingesting even minute amounts of DDT, which, because of its long-lived nature, suggested the specter of mass pelican deaths for many years to come.

The DDT question will be discussed in detail later in this book, but it seems important at the outset to place its threat in the proper perspective. We know that in California the population decline reversed itself after the United States government banned DDT's use in this country. DDT, which has been credited with saving as many as 100 million human lives since its discovery by a Swiss scientist in

the 1930s, stood indicted as the most persistent cause of what appeared to be an irreversible decline of one of the oldest species of birds on earth.

The evidence against DDT was hardly flimsy. It did not come from the backyard laboratories of amateurs or crackpots, but from leading scientific institutions around the world. And when this mass of evidence was all in, the solution to the brown pelican's endangered status seemed too simple to be true: banish DDT, and the brown pelican would be saved.

Indeed, the pelican *has* come back, and in remarkable numbers over a relatively short period of time. But in that very fact there is a pitfall to be avoided. Certainly, from all the evidence, DDT seemed to be a major influence in the decline of the brown pelican; its renewed use—or, more properly put, its misuse—would doubtless cause the bird's population to plummet once again. But after the comeback began, after DDT was outlawed, pelican populations at some locations continued to suffer severe "crashes." Some causes are the same ones faced by pelicans long before DDT was even invented. Others still puzzle scientists, who are seeking answers.

What is important to realize, then, is that DDT is but *one* factor among many, that DDT alone cannot be blamed for the brown pelican's near-demise. It is not enough to say smugly, "Ban DDT and the pelican will prosper." Loss of suitable environment is another adverse factor. Disturbance by man is certainly another. During the research for this book, for instance, Dan Guravich and I were observing a colony of nesting pelicans on Louisiana's Queen Bess Island one chilly, drizzling December day. While we watched, a local gill-net fisherman, oblivious to the fact that brown pelicans were nesting in the area, moved his boat to within a few yards of the island's shell beach. The birds, alarmed at the fisherman's arrival, left their nests, which fortunately, were empty due to the fact that herring gulls had robbed them of 104 eggs. Had there been newly hatched chicks in the nests, however, all would have died from exposure before the fisherman moved away twenty minutes later.

As another example, Dr. Joseph Jehl, then of the San Diego Museum of Natural History, noted a similar incident on the island of San Martín, off the coast of Baja California, when a group of well-intentioned but apparently uninformed visitors, stopping at the island while en route to the Baja California gray whale calving grounds farther south, frightened at least twenty nesting pelicans from their nests merely by tramping through nearby brush.

There are many other reasons, despite reports of a comeback, that the brown pelican is still very much a threatened species, and it would be unwise indeed to assume that because DDT is no longer used in the United States the bird may one day soon be seen in the vast numbers described by Audubon. I hope that this book will be received not only as a celebration of the brown pelican, but in some measure as a guide to the steps we must take if this magnificent bird, in the United States, is to avoid the fate of its long-vanished cousins, the passenger pigeon and the Carolina parakeet.

1

A Wonderful Bird

Louisiana Cajun fishermen call him *grand gosier*—"big gullet"—an affectionate reference to the gawky throat that is his most prominent feature. Preserving his image as a symbol of the sea, mariners have named ships after him and carved his likeness in whalebone scrimshaw. At least four islands bear his name, including the former penal colony in San Francisco Bay, Alcatraz, which is his name in Spanish. He is referred to in the Bible; in the Psalms and prophesies of the Israelites he was a symbol of loneliness and unhappiness.

To ornithologists and others who find grace and purpose in his clumsiness, nobility in his ugliness, the brown pelican is one of the most remarkable birds on earth, a species that has changed little in the thirty million years of its existence, and to which respect is due if for no other reason than its hardy durability.

A bird that fascinates both amateur and scientist, the brown pelican is one of eight species of the family *Pelecanidae*—all fish-eating birds characterized by a large pouch, extremely long bill, and webbed feet. Of the eight species, two, the brown pelican and white pelican, are found in the Western Hemisphere, the remaining six in the Old World. Although the brown pelican is related to the others, he is distinctly different in many respects—his method of diving for his food, for instance, and the fact that he does not migrate seasonally but prefers to remain close to his colony year-round, always near the sea. There are marked physical differences and differences in behavior, even among brown pelicans found along the West Coast of North America, and those that inhabit the Gulf and Atlantic coasts, mainly in Florida and Louisiana.

The *Pelecanidae* are all fisheaters, and all are associated with wa-

ter. The brown pelican, however, is one of the species that inhabits only marine areas; some of the others range in inland waters, or migrate from saltwater habitats to those in freshwater.

Although white pelicans in the Old and New worlds are considered as separate and distinct species, most ornithologists believe that because of their close resemblance they had a common ancestry. "Pelicans became pelicans long before man became man," Dr. Frank M. Chapman noted in 1908 in one of the earliest important studies of these birds, and "a study of the distribution of the existing species leads to the conclusion that at least as late as the latter part of the Tertiary period our white pelican, and doubtless also other species, presented much the same appearance as it does today." On the question of common ancestry, Dr. Chapman wrote:

> Of the . . . Old World species, the one inhabiting southern Europe so closely resembles our American white pelican that early ornithologists regarded them as identical. Nevertheless, the localities at which their ranges are nearest are separated by some 8,000 miles. Such close resemblance, however, is neither an accident of birth or breeding. Pelicans did not appear independently in the two hemispheres. Birds so like each other and so unlike other existing birds must have a common ancestor. Common ancestry implies, at some time, continuity of range, and with the European and American white pelican we may well believe this to have occurred in that latter portion of the Tertiary period when a warm-temperate or even sub-tropical circumpolar climate existed.

The brown pelican, *Pelecanus occidentalis*, is one of the world's largest birds. Adults measure 50 inches from their broad webbed feet to the tip of their 12-inch (300 mm) bill. The adult plumage in summer, the off-breeding season, is silver-gray on the back and wing feathers. The head is white with light blue eyes and a chocolate-brown neck. The bill is a chalky yellowish white, the belly slate colored.

In early fall, after the body molt, the chocolate-brown neck turns to snowy white and the white head becomes gold. The bill changes in color to various sunset shades. An olive-green color appears in the pouch in the East Coast pelican. The West Coast pelican's pouch becomes dark gray with reddish hues. In both populations, the gray tissue around the eye becomes a reddish pink. This plumage is the mating, breeding, or winter plumage.

These changes apply only to the mature pelican, however, for the birds go through a very complicated series of plumage changes from the time they are hatched until they reach the age of about four years.

Brown pelican chicks are hatched naked and pink, turning to a purplish hue after 24 hours. On close observation pin feathers can be seen protruding through certain areas of the skin, and down feathers (neossoptiles) can barely be seen just under the skin. At this age the chick must be closely guarded by the parents since they cannot yet regulate their body temperature.

Soft white down will have completely covered the body by three to three and a half weeks; at this age, the chicks do not require as much protection, and by the time they are ready to fledge—leave their nests—at eleven or twelve weeks, all major feathers will be in. The belly down will be replaced with white juvenile feathers. The head, back, and neck will be a feathering of light greyish brown. During the two to four years it takes for the chick to attain adulthood, its plumage continues to change, the white belly feathers turning gradually to slate, and the head and neck feathers to white.

Dr. Ralph Schreiber, formerly of the University of South Florida, now a zoologist with the Los Angeles Museum of Natural History, who has closely observed the life cycle of the brown pelican in Florida, notes that the plumage changes even seasonally after the bird becomes an adult, and this change is among the most elaborate found in the bird world. During the period of courtship in spring, for

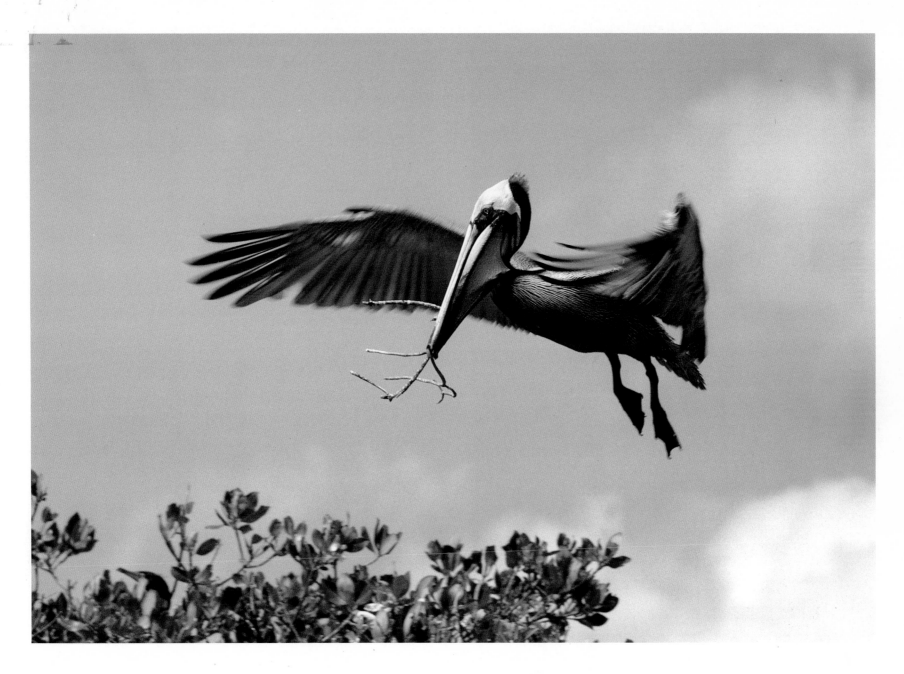

A brown pelican brings nesting material into the mangrove rookery. Both in taking off and landing, the pelican faces into the wind. The wings, extended and cupped, are **7** used for braking, much like a parachute. For balance and additional braking, the feet are extended downward.

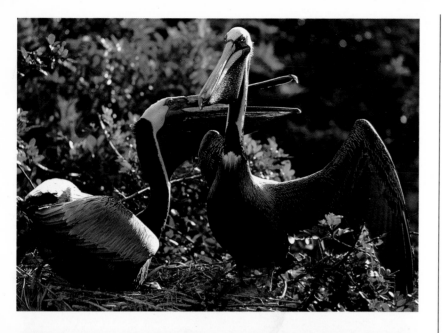

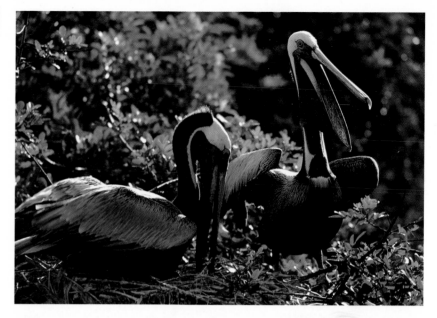

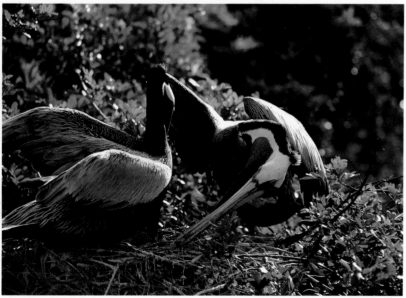

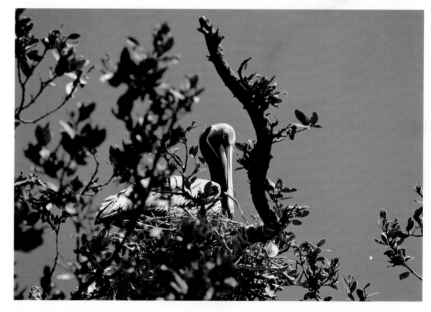

Above: A male brown pelican has placed a twig on the nest, after which will follow some of the ritual of courtship. *Below* : The male reaches under the female to position a twig recently delivered.

8

Above: The female makes a final placement of the twig. *Below*: Another female manipulates a twig that has been brought in by her mate.

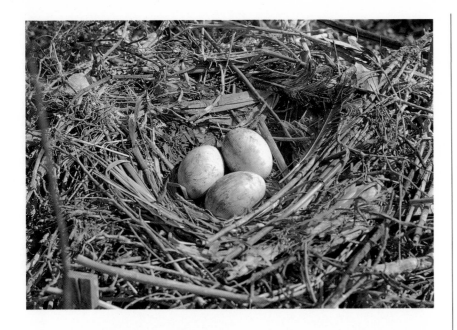

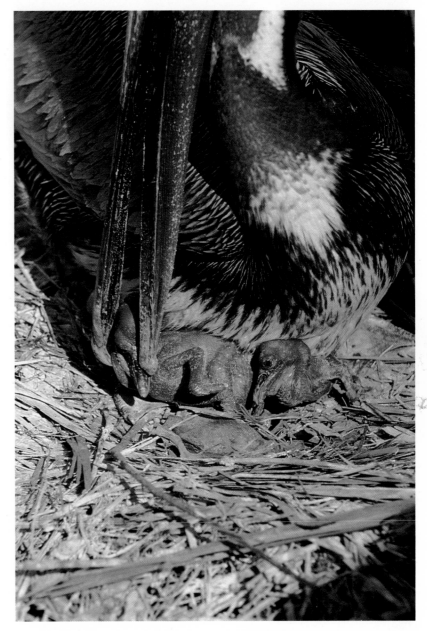

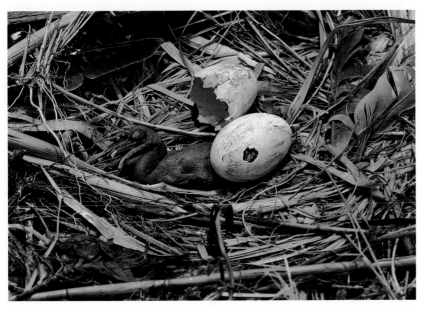

Above: The average nest contains three eggs. *Below*: At this stage and for the next several days the hatchlings are extremely vulnerable to temperature change.

Occasionally a parent will step on a hatchling. This female has crushed one of her three chicks and is carefully moving one of the other two.

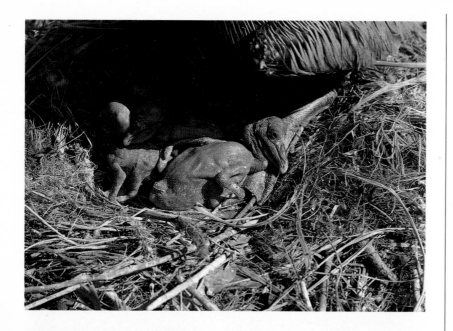

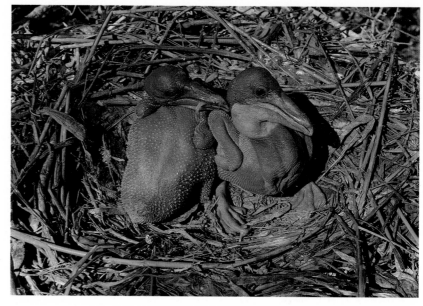

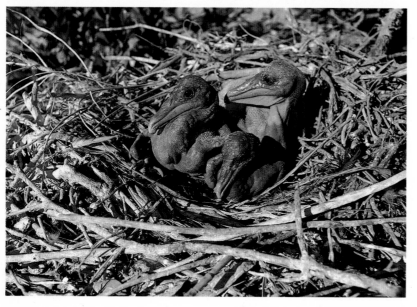

Brown pelicans at three early stages of growth. *Above left*: eight to twelve days; *below left*: two to three weeks; and *above*: three to four weeks. Almost from the moment of hatching, chicks are noisy creatures, peeping, squawking, screaming. Only when it is asleep is a chick silent.

Right: This pair of naked chicks is five weeks old. Featherless when hatched, the baby pelican is obviously not beautiful. Its bill is awkwardly long, and its feet disproportionately large. Soft white down begins to cover the chick by three and a half weeks.

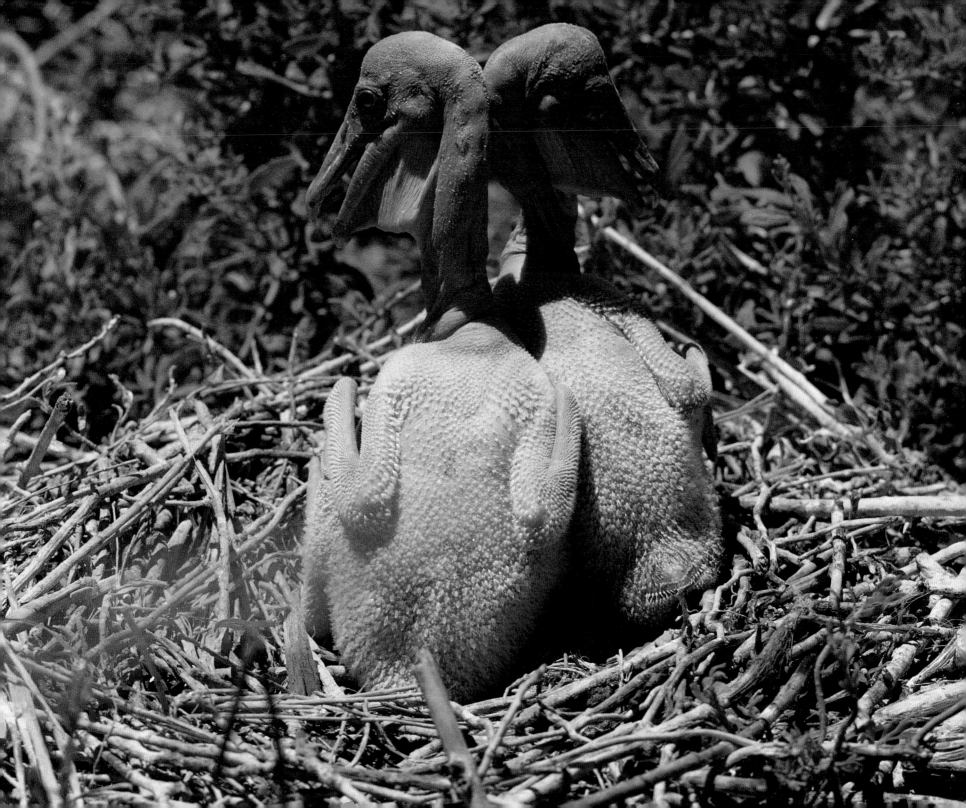

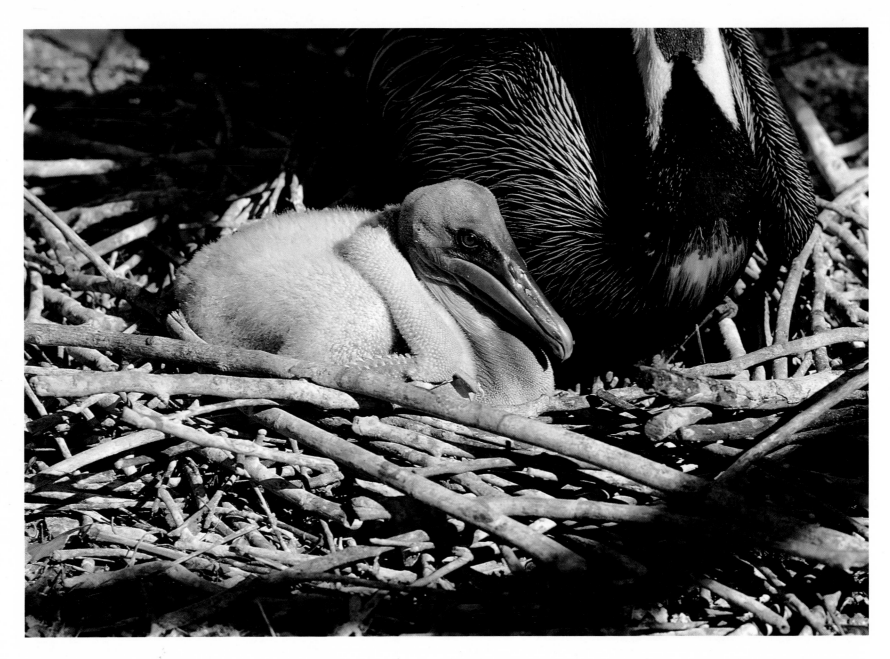

Above: This chick rests contentedly beside its parent. It is approximately six weeks old and is no longer dangerously sensitive to changes of temperature. Like human newborns, the baby pelican's demands are simple; all they want is food and sleep.

Right: Two chicks at six to seven weeks are showing growth and strength from a steady diet of fish. They must store up body fat, for they fledge at twelve weeks and leave the nest shortly thereafter.

12

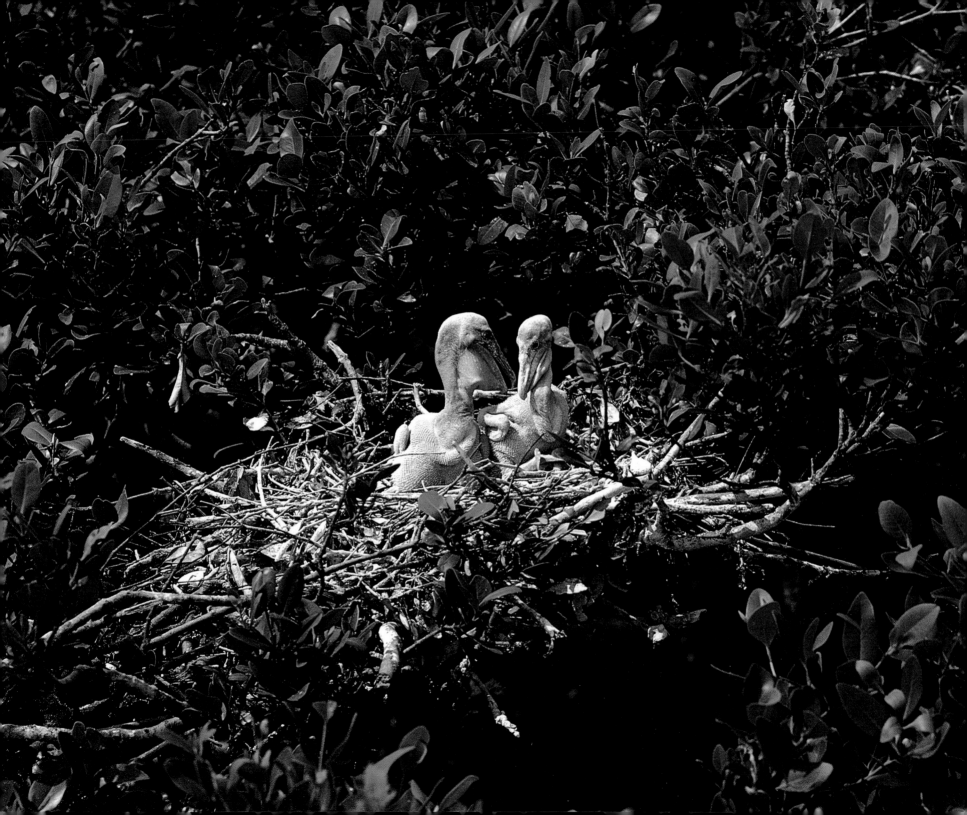

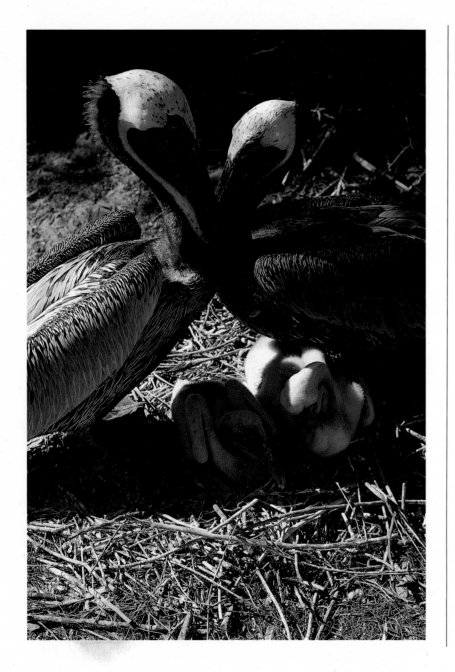

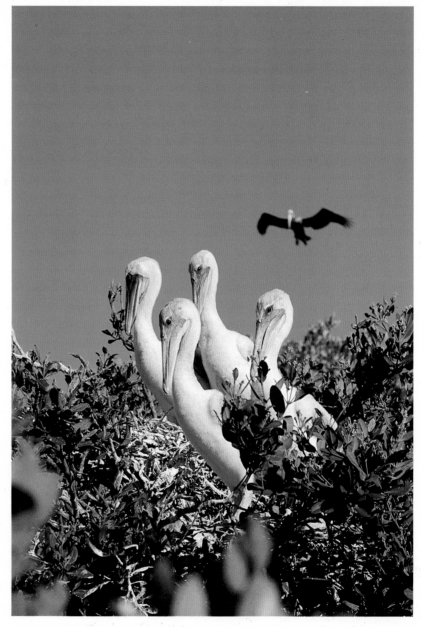

These six-to-seven-week-old-nestlings, having been fed, are resting contentedly below their parents.

A nestful of hungry eight-week-old birds waits patiently for the photographer to leave so the circling parent overhead can return to the nest with food.

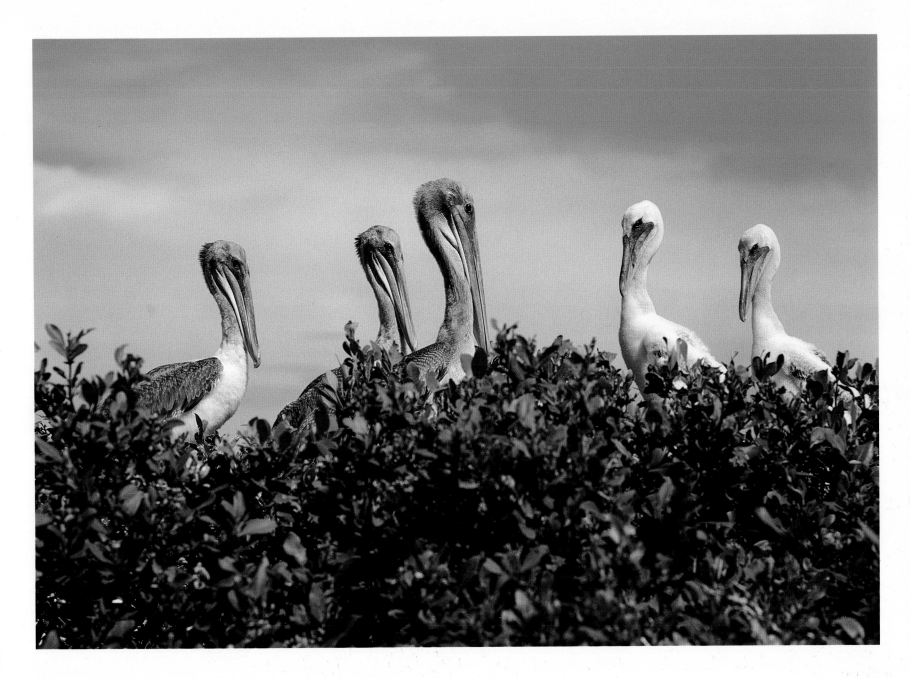

Two nests sit side by side in the top of a mangrove tree. The juveniles on the left are
twelve weeks old. The chicks on the right are eight weeks.

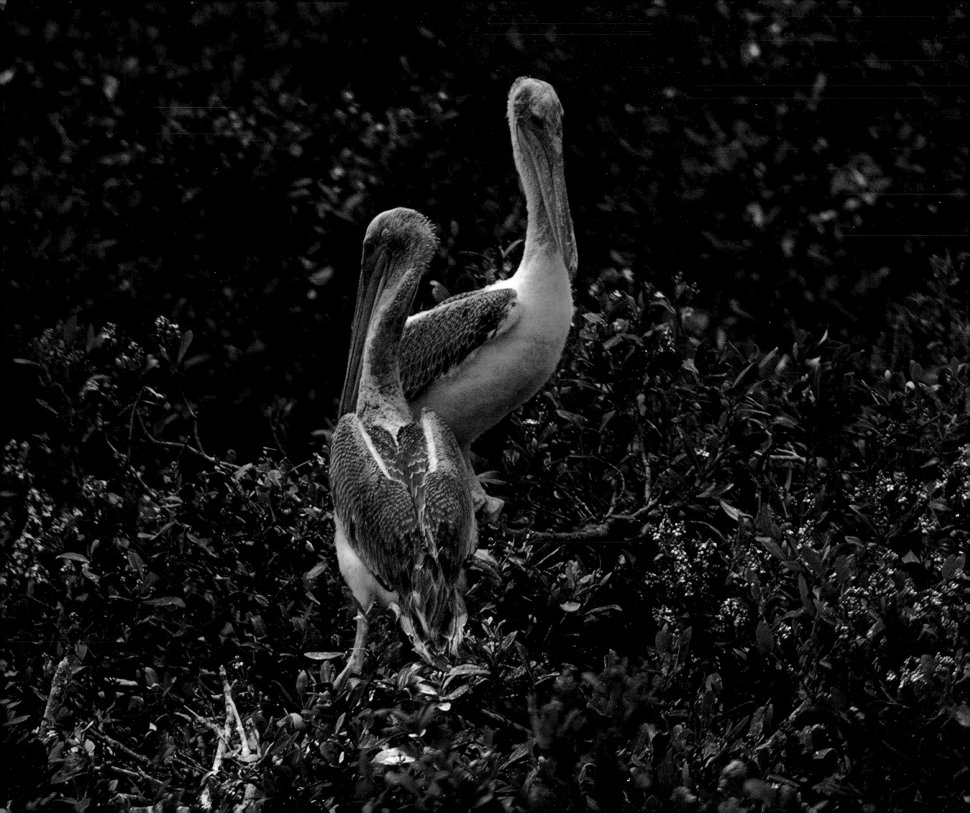

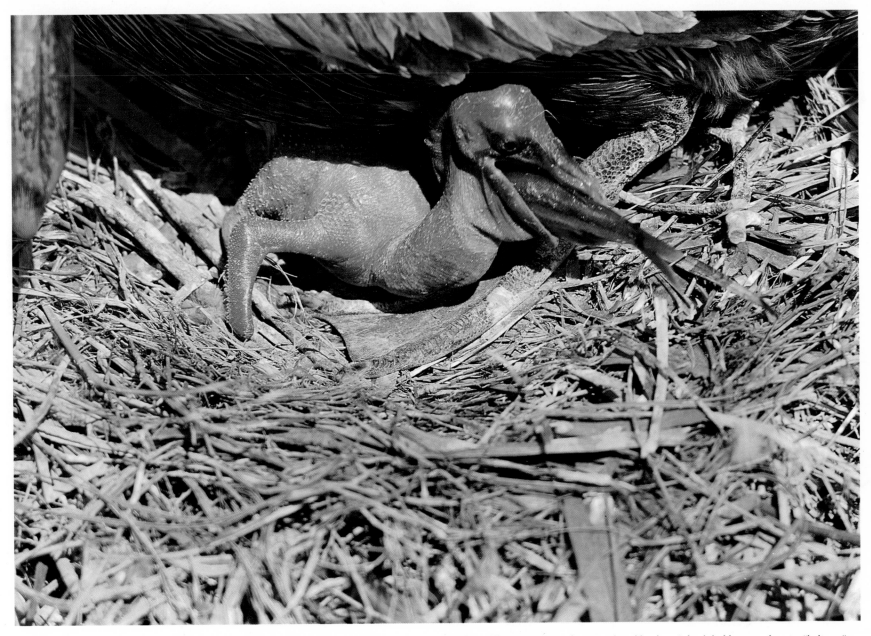

Left: Pelican chicks at twelve weeks are about ready to fledge, when they will enter the do-or-die period of learning to fish.

Above: This approximately seven-day-old pelican's beak holds more than its "belican." One or two such fish regurgitated by the parent are required to fulfill a new pelican's daily demands, and for about the first ten days the chicks are fed directly by either parent.

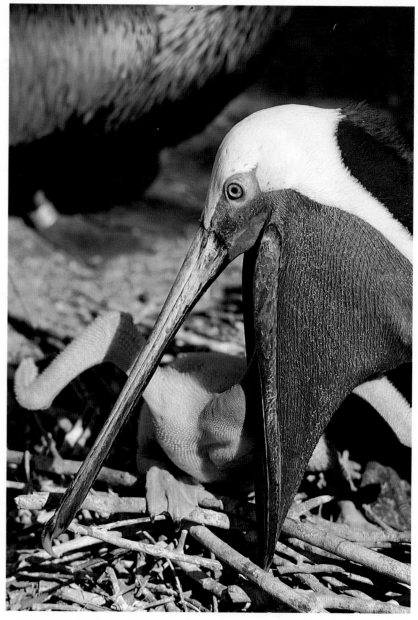

This five-week-old pelican is attempting to take food from its mother's pouch.

18

A six- or seven-week-old is almost able to reach into the gullet, and in this picture, the outline of the nestling's bill can be seen in the top of the parent's pouch.

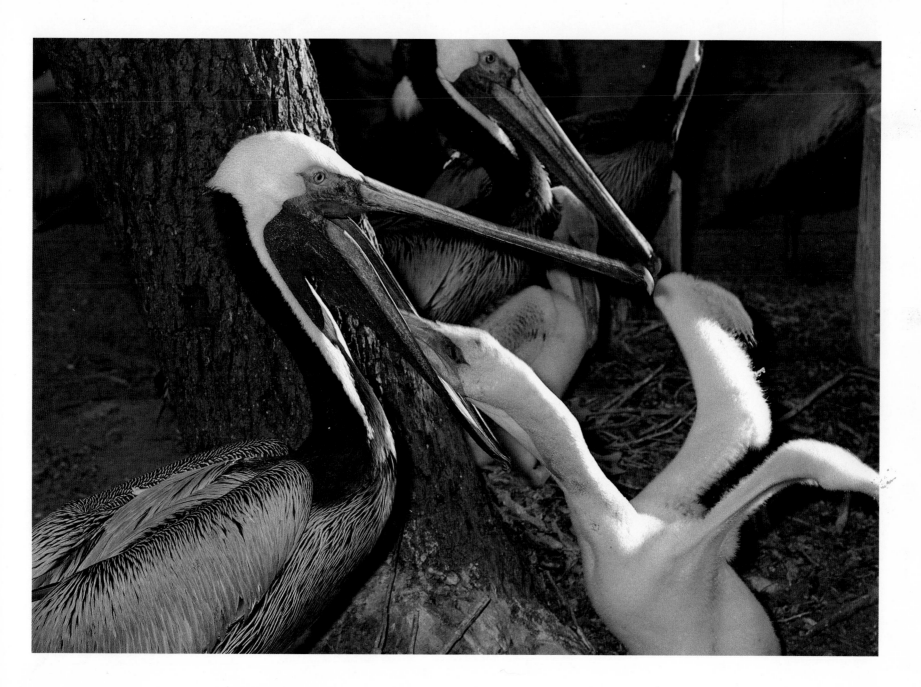

At six weeks this chick is strong enough to reach into its parent's pouch. For a nest of three chicks, parents must find and bring back six to nine pounds of fish each day. **19**

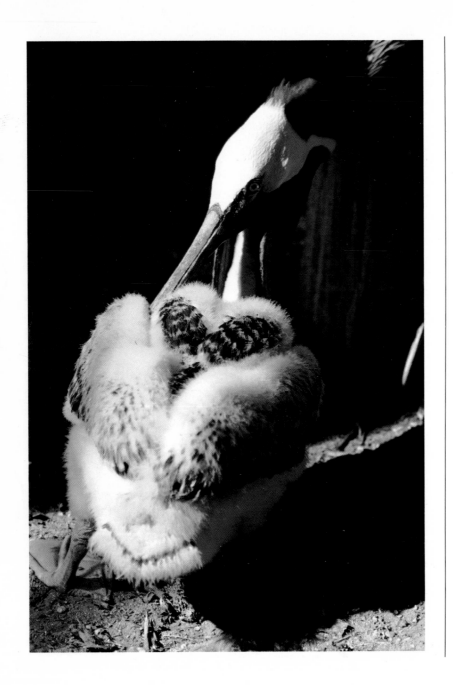

Left: This nestling, partially feathered, is reaching into its parent's gullet for fish. In another two weeks this youngster will fledge and will have to learn to catch his own fish.

Right: During the frenzy of feeding, youngsters get carried away and will try to eat anything, including each other.

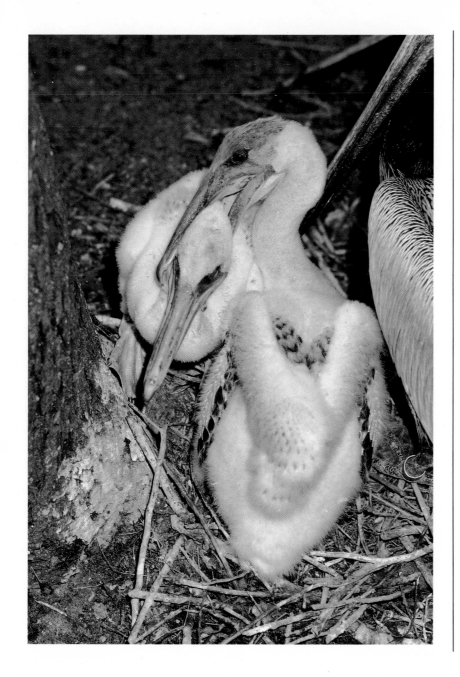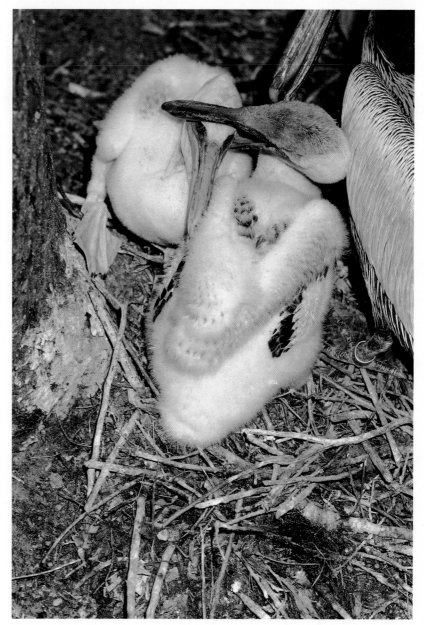

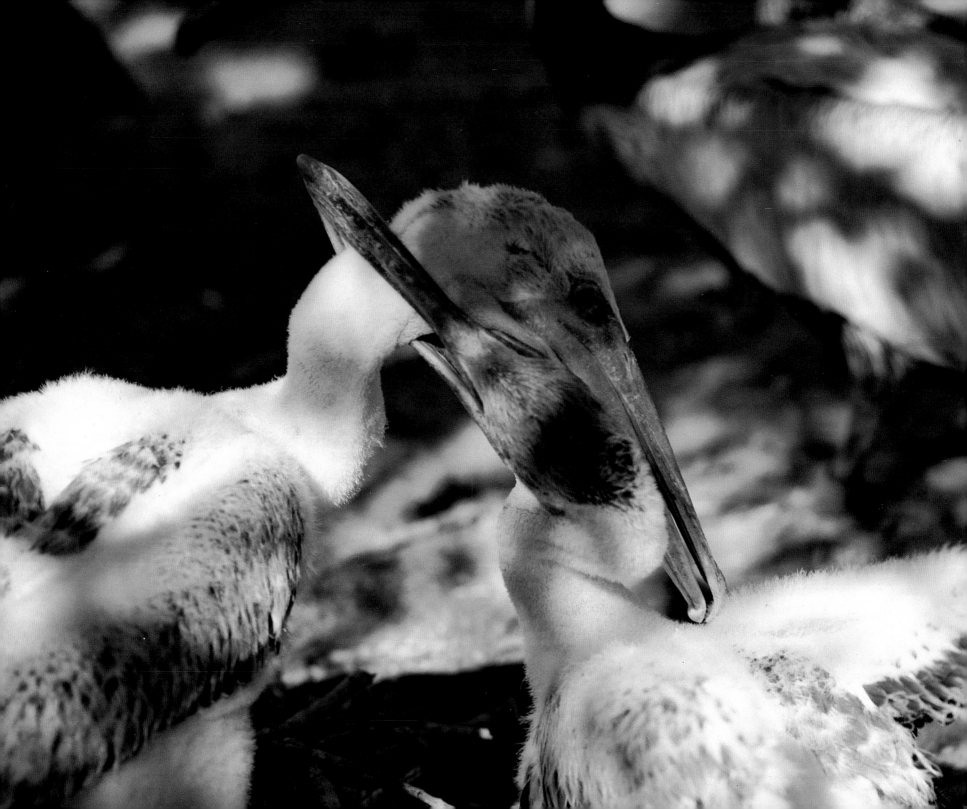

example, adults are brightly, even gaudily, colored, and although the colors fade following courtship, they become very bright once again as the breeding period nears.

Below the pelican's prominent bill (actually its upper and lower jaws, or mandibles) is the equally prominent pouch, a flexible bag used to scoop up fish. The bird does *not* store fish in either pouch or bill as suggested by Dixon Lanier Merritt in his delightful 1910 limerick:

> A wonderful bird is the pelican,
> His bill will hold more than his belican.
> He can take in his beak
> Food enough for a week,
> But I'm damned if I see how the helican.

The upper part of the beak is flattened; the lower part carries the pouch that can be distended to grotesque proportions and which, on the adult bird, can hold fully seventeen pints of water. A small hook at the end of the bill is mainly used to preen feathers, but is also used to turn eggs in the nest. And many an unwary observer has learned it can also be used as an effective but painful weapon.

Of special interest to biologists are the pelican's webbed feet. However, unlike other web-footed birds, pelicans have four toes rather than three. The toes are connected by thick webbing, and the third toe has a long claw, which is used to preen behind the neck. The webbing is also an aid to swimming, and the toes are flexible enough to allow the bird to firmly grip a tree limb or other perch.

At almost no time in its life does the brown pelican venture far from the water. In addition to its range in coastal California, Texas, Louisiana, and Florida, the bird occurs throughout the coastal Caribbean and along the coasts of Central and South America. Brown pelicans from central northern Peru to Chile are larger than their northern cousins, and some ornithologists consider the North American bird a separate species from the Peruvian pelican.

Pelicans nest near salt water, sometimes so near that they mis-judge tide and storm, and eggs are lost. They depend upon water entirely for their food. And on at least one occasion a group of brown pelicans demonstrated that even at the expense of additional time and energy, they prefer to fly over, or at least near, water. That occasion was just before the turn of the twentieth century when A. W. Anthony, studying *Pelecanus occidentalis* on the offshore islands of Baja California, noted that "After reaching the head of [a] bay, ten miles from the feeding grounds, they turned through a pass between the hills, and after flying five miles over the land, reached the ocean at a point opposite the island, having flown eighteen or twenty miles to reach a point ten miles distant, rather than fly two miles over a range of hills one hundred feet high (but much further from the sea)."

John James Audubon recorded more than a century ago that brown pelicans, like experienced sailors, possess an uncanny instinct for the rise and fall of tides and for imminent change in the weather. They may be sound alseep in their seaside colonies, Audubon observed, "yet without bell or other warning, they suddenly open their eyelids, and leave their roosts, the instant when the waters, which have themselves reposed for awhile, resume their motion." The naturalist suggested that because of the pelican's ability to "judge with certainty . . . the changes of weather," seafaring men would do well to check the behavior of the local pelican population before venturing far out to sea. If the pelicans remain huddled close inshore, the chances are good that foul weather is brewing. "But if they pursue their finny prey far out at sea, the weather will be fine, and you may also launch your bark and go fishing."

For many of the same reasons that man thinks of the dolphin, the albatross, and the shark when he thinks of the sea, he has often affixed the pelican's name to his maritime endeavors. Before it became the *Golden Hind*, for instance, Sir Francis Drake's flagship, one of the first vessels to circumnavigate the globe, was named the *Pelican*. In the War of 1812, it was a British man-of-war *Pelican* that

forced the American battleship *Argus* to surrender in a battle in the English Channel. At least two marine animals carry *pelican* as part of their name: the pelican foot, a tiny mollusk whose sharp spikes resemble the four-toed webbed foot of the seabird, and the pelican fish, an unusually deep-dwelling animal whose stomach can be distended like the pelican's pouch.

Early Christians adopted the pelican as a symbol of Christ's sacrifice on the cross, and the bird's image appears frequently in religious literature including the Bible. In the Book of Psalms is found: "I am like a pelican of the wilderness; and like an owl that is in the desert. I have watched, and am even as it were a sparrow: that sitteth alone upon the house top."

Perhaps the most repeated legend is that if the mother pelican cannot find food for her nesting young, she will slash her chest to give them succor from her own warm blood. The image of the bleeding mother bird appears frequently in heraldry, including on the seal of the state of Louisiana, and there are many theories as to where the legend originated. The most likely source is the red tip of the parent pelican's beak, suggesting that it has been dipped in blood. In his *Love for Love*, the seventeenth-century writer William Cosgrove alluded to the legend: "What, wouldst thou have me turn pelican, and feed thee out of my own vitals?" Early civilizations apparently accepted the pelican sacrificing herself for her young as a symbol of charity and piety, and this may explain why the figure of the pelican appears on many shields and badges of heraldry.

A different version of the legend was written by Bartholomew in 1535. Instead of the bloodletting being an act of kindness on the mother pelican's part, he said, it was the other way around; the mother pelican killed her chicks in retaliation for their having struck her in the face, and three days later, repentent over her act, she drew blood from her chest in an effort to revive them.

With or without legends—and at the risk of anthropomorphism— pelicans are birds that possess many of the traits that we consider laudatory among humans. Parent pelicans will fiercely defend their nests and their young from intruders. They do not seem disturbed when scavenging gulls flutter around them, even lighting on their heads to snare fish from their beaks; seldom do pelicans attack the pesky fish thieves, though their tough mandibles are formidable and if swung in force, could maim and possibly kill. Pelicans are doting, protective parents, sharing the responsibility for incubating their eggs and for feeding their young. In a sense, the brown pelican is a pacifist of the bird world, epitomizing a spirit of peaceful live-and-let-live coexistence.

Brown pelicans nest in colonies, usually on islands where populations may range up to several thousand pairs. Lacking islands, they prefer sites as close to the sea as possible, where there is less likelihood of mammal predators. Other birds, however, prey on pelican eggs or hatched young, frequently stealing eggs when parents-to-be have been frightened away from their nests. In Florida and throughout the coastal Caribbean, brown pelicans usually nest several feet above the ground in mangrove trees. Elsewhere along the Gulf of Mexico, as well as in California, they nest on the ground. On the flat coast of Louisiana, this means almost at sea level, and frequently nests are destroyed by tidal surges and stormy seas.

Among the pelican colonies on the offshore islands of California and Mexico's Baja California, nests are built much higher, often in rocky crags thirty or forty feet above the water. In these colonies, life between breeding seasons alternates between utilitarian pursuits, such as food-gathering, resting, and almost constant preening of feathers. Preening is not a cosmetic function, but a necessary one.

Pelicans rest on their colonial islands or float in the water, the latter reminding Audubon of "a fleet at anchor, riding on the ever-rolling billows as unconcernedly as on shore." On solid ground, pelicans almost stumble along, yet they seem no more clumsy than waddling ducks or swans. And once aloft, pelicans assume a grace and stature perhaps unexcelled by any other bird.

Because of the pelican's size and weight, it must give many hefty flaps of its wings to become airborne; only then, after retracting its feet and tucking its mandible on the front of its neck, does its superb aerodynamic design become useful. After takeoff, flight seems almost effortless, an impression underscored by the slow wing-flapping that is characteristic of all large birds.

In groups, brown pelicans usually fly both in the common V-formation of many bird species and in an angled slash line (/). The formation is so tight that the lead pelican, with no birds ahead of him, must exert more effort than the others to maintain the same flying speed. Each pelican uses the turbulence created by the bird ahead for extra lift. The principle is much the same as that of a race-car driver riding closely behind a competitor; wind resistance is lowered and less power is required. For this reason, pelicans alternate positions in formation, the leader dropping back in the middle of the formation to rest while a new, temporary leader takes its place.

Brown pelicans seem to be able to judge what altitude requires the least effort. During their evolution, they have learned well the vulture's trick of riding thermal currents, warmer columns of air rising to great heights. Riding a thermal, the pelican alternately glides and soars, just as the pilot of a sailplane does, flapping its wings only occasionally.

When thermals are absent or when headwinds become a problem, pelicans descend almost to sea level. There, with their wings almost touching the water, they practice their technique of "troughing"—flying through the valleys between the waves, protected from the wind. Flying low creates a cushion of air beneath, which reduces the effort required of the bird.

Like all birds, pelicans fly by the same aerodynamic principles as the airplane. Wings provide both lift and steering; it is equally correct to say that, because they turn by shifting their body weight in tandem with maneuvers of their wings, the principle that guides them is the same one that governs the flight of the increasingly popular hang

gliders. Both in taking off and in landing, pelicans face into the wind, gaining maximum lift. Like the "kite" of the hang-glider pilot, the pelican's wings are used as a parachute brake for landing. The feet are always extended downward and expanded fully for added braking control.

When the wind is calm, the pelican alighting on either land or water slightly tilts its body backward, flaps its broad wings three or four times to brake itself, then settles to rest. It is only then (on land) that it once again appears an awkward, clumsy creature.

Although more scientific studies have been made of the brown pelican than of any of the other seven pelican species in both Northern and Southern hemispheres, the cruising range of this seabird is not precisely known. It has been estimated, however, that an adult brown pelican, which does not travel long distances each year like the white pelican, flies out a maximum of 25 miles and back again—a round trip of fity miles—during its daily forays for food. The range is important, because it means the brown pelican must have an ample food supply relatively close at hand. Especially during the nesting season, trouble looms if for some reason a familiar fish supply has been drastically decreased or has disappeared altogether. For example, millions of seabirds, including cormarants, boobies, and the brown pelican, the major guano species, die of starvation during the periodic "crashes" of the anchovy population off the coast of Peru.

Brown pelicans feed in flight, and the sight of a flock diving upon a school of fish is one of the most spectacular in nature. Rarely have they been observed feeding, as their white pelican cousins do, which is by forming a large circle on the water and "herding" fish into an imaginary corral where they easily can be captured in their saclike pouches.

Diving requires experience and keen judgment. The altitude from which the bird begins his plunge depends upon his knowledge of his own body weight and just how deeply he will plunge from any given altitude. The pelican must estimate the fish's size, depth, and speed

very closely; as goggled human divers well know, the visual physics involved in estimating from above the size or position of underwater objects can become quite complicated and deceiving.

The brown pelican's main diet consists of trash fish—menhaden, anchovies, mullet, and, occasionally, sardines. During World War II, when both manpower and food were in short supply, Gulf Coast fishermen complained that they could return greater catches of fish for human consumption if they did not have the brown pelican and his appetite to contend with; would it not be reasonable to destroy enough of the birds to reduce the competition? But Dr. Alexander Wetmore, who later became a research associate at the Smithsonian Institution, had proved shortly after World War I that pelicans prefer trash fish. If the gulf's brown pelicans were to seek a human champion, Wetmore doubtless would be a leading candidate for the honor; his study probably prevented a mass slaughter of the bird.

Most fish that brown pelicans catch lie within a foot or two of the surface. For obvious reasons, he seeks out schools rather than single fish. (The tightly bunched schooling of small bait fishes such as the anchovy—a natural form of self-defense against underwater predators such as sharks, which apparently are intimidated by the collective and somewhat forebidding size of the school—does not deter the pelican.)

Attaining the proper altitude (usually from ten to twenty feet above the water) the pelican begins his dive with wings halfway folded back, feet held forward and neck tucked back. As it descends and its speed increases, it stretches its feet straight back under the tail, wings flattened tightly back, and neck outstretched. The point of his bill is pointed directly downward, the expandable pouch still held tightly shut. Not until the tip of the bill touches the water does the bill open and the pouch expand, scooping up as many fish as can be quickly caught—often hundreds of small minnows along with several gallons of water. The approach to the dive is made downwind. As soon as the pelican has gathered his catch in his pouch and tight-ened it shut, he turns around *underwater*, facing the wind, before surfacing. At this point, the pelican is floating upright on the water, with his bill still pointed downward. When the water drains out the sides of the mandible, the pelican swallows the larger fish headfirst—fishes' backward-sloping gills would injure his throat if swallowed tail first, and must sometimes be turned around—and takes off, using the wind for necessary lift.

The brown pelican's fish capture has long fascinated scientists, but it was not until recent years that they were able to verify the phase of the process that occurs underwater. In a marina in Florida, Ralph Schreiber along with Glen E. Woolfenden and William E. Curtsinger placed a motorized camera approximately two feet underwater and baited the area with frozen fish. Admittedly, Schrieber reported, the photographs were obtained under "somewhat unnatural circumstances," although "We believe they accurately represent the technique brown pelicans use when diving to catch live fish."

Schreiber believes that the pelican dives for an individual fish, even if it is part of a school. The pelican keeps its head stable to allow sighting down its long bill, just as a hunter might sight down a gun barrel at his intended prey. The bird can correct its dive in flight; bending the wings astern increases speed; moving the wingtips up or down, just as an airplane elevator would function, corrects its aim.

"A bird has nothing resembling an airplane rudder," Schreiber and his colleagues reported on the experiment in *The Auk*, a journal of the American Ornithologists Union, "and normally changes course in level flight by a banked turn. To correct for right or left in a fast dive, the pelican rotates its body, but not its head, by raising one wingtip and lowering the other."

In some dives noted by Schreiber, pelicans rotated their bodies a full 180 degrees—a complete half circle—entering the water at various angles. Upon water contact, the legs and wings were thrust back, streamlining the downward-hurtling bird and accelerating the movement of the bill at the moment of surrounding the prey. Schrei-

ber estimates that less than two seconds pass between the time the pelican's bill touches the water and the target fish is entrapped; often "up to a minute is needed to drain the pouch and swallow the fish."

If no catch is made, the head and bill rapidly return to the normal position. The study did not speculate on the percentage of successful diving captures, although by carefully noting the postplunging behavior and timing the bird's emergence from the water, a close approximation can be made.

Despite the spectacular rapid dive of the pelican, the bird sometimes will terminate its plunge and fly away only a split second before touching the water. It is not known whether this occurs only when the bird has targeted a single fish that suddenly veers out of range, or whether it also happens when an entire school is in the target area.

The pelican seldom takes fish longer than his bill, and ordinarily he feeds upon fish much smaller. Neither does he return to his colony with fish in his pouch; like an airplane, his weight must be carefully balanced fore and aft, and a nose-heavy pelican cannot fly any more than could an airplane with all its baggage and passengers crammed into the pilot's compartment. Quite often when they are frightened, while at rest on the water (by an approaching boat), they will regurgitate hundreds of minnows before taking off—perhaps to lighten their load.

Audubon was among the first to record that brown pelicans often locate schools of fish by the proximity of fish-eating porpoises (porpoises serve the same purpose to commercial fishermen). In turn the splashing of feeding pelicans often attracts flocks of other interloping waterbirds, notably gulls and terns. As mentioned earlier, if the scavengers seem too insistent, the pelicans often fly off rather than fight back. Observing this phenomenon in the Galapagos Islands in 1913, Edward W. Gifford wrote: "It was not unusual to see several noddies fluttering excitedly about a pelican when it was fishing, and often sitting on its head while it swallowed a fish. Once, I saw two on a pelican's head at one time. The pelicans never seemed to be annoyed, nor did the noddies ever get any fish as far as I could see. Dusky shearwaters would occasionally fly about a pelican, apparently to pester it, for one day I observed a pelican take refuge on the top of a cliff from a number of them."

As they mature, brown pelicans lose their vocal powers and become almost mute. For this reason, the drama of colonization, flight, and the spectacular ritual of diving for food is a silent one. Yet, in ways no less intriguing than sound do they make themselves and their intentions known, as the season of courtship, breeding, and parenthood begins each year.

2

All in the Family

For the brown pelican, family-building is a time for elaborate displays of affection. Although the season of courtship, nest-building, mating, egg-laying, incubation, hatching, and fledging varies from area to area, this important cycle of life generally takes place from late winter through early spring and covers four to five months of the year.

It is one of the most critical times in the life of the brown pelican, for an enormous number of adverse factors come into play. There are few natural predators to disturb the fledged or adult bird, but during the reproductive season, weather, other natural phenomena, mammals and other birds can threaten or even reduce the bird's population.

Courtship is the phase in which the male pelican, which does not invariably mate for life, chooses his mate and invites her to join him in building their nest. To neither male nor female pelican, both now festooned in their brightest colors, is courtship a hasty affair. In some colonies, it has been observed that an adult male may take many days to entice a female to become his partner for that season. His display consists of repeated sideways head movements in the shape of a figure eight. The gesture is repeated perhaps a dozen times before one of the colony's female birds accepts him and the nesting site he has chosen.

To the brown pelican, courtship is a silent, almost solemn affair, a ritual that seemed to one early observer, Stanley Clisby Arthur, more fitting with the end of life than the preparation for its beginning. After watching courtship at a pelican colony in Louisiana, Arthur recorded the following, certainly a minor classic among *Pelicanid* literature:

The courtship of the pelican is quite what one would expect from a bird of its other undemonstrative habits. I witnessed it . . . on Isle Grand Gosier and it marks the only time I have seen a pair of brown pelicans together where I could unhesitatingly identify the male from its mate. The female squatted close to the bare ground while the male circled her with ponderous, elephantine tread. While he circumnavigated the course he lifted his wings slightly and tilted his neck far back, but there was none of the pronounced strutting usually indulged in by other birds, particularly those of the gallinaceous order. Both wore most lugubrious expressions during the whole courtship and the occasion was more befitting the solemnity of a funeral than the joyous display attending most nuptials. Neither uttered an audible sound while the male pursued his dignified circuitous meandering. Suddenly, she rose from her squatting position with a *gruff-gruff* of wing strokes and flew to the ocean but a short distance from the shore, and after stolidly watching her going, he followed, still wearing the mask-like expression of weighty solemnity, to the consumation of the courtship on the surface of the quiet swelling waters of the gulf.

Webster defines *lugubrious* as "very sad; mournful; dismal; doleful, usually implying ridiculously excessive grief." Although it may be questioned whether pelican courtship properly fits this definition, the solemnity of the occasion has frequently been observed, and it is altered only slightly even when the female accepts her mate. Now, having made a preliminary exploration of whether they should share a nesting site and join in parenthood, the male and female begin a series of aggressive and submissive posturings to conclude the question.

This is a delicate and often time-consuming phase of courtship. By posturing aggressively, each bird is indicating the desire to protect the possible nesting site and to drive intruders away. But if the male postures *too* aggressively, he will frighten the female away. The submissive gestures are invitations; they say, in effect, "Will you share this nest with me?" If, on the other hand, the male is overly submis-

sive, more aggressive males may take this as a signal of weakness and drive him from the site.

Courtship has often been observed in the birds' natural habitat, and it has been recorded in capitivity among crippled birds and free flyers.

A rare occurrence at the time was the breeding of captive brown pelicans in 1974 at the Suncoast Seabird Sanctuary in Redington Shores, Florida, a privately funded "bird hospital" founded and operated by a dedicated young man named Ralph Heath, Jr. (whose work is described in greater detail later in this book.)

Since all of Heath's feathered patients have come to Redington Shores injured, disabled, or sick, they may not be considered typical of a natural, healthy brown pelican population in the wild. Yet, as Heath points out, courtship and nesting behavior of captive, crippled brown pelicans is similar to the behavior observed in the wild. For two or three years there has been a small but growing colony of wild birds nesting above the breeding pens at the sanctuary, and correlating information from each has produced a valuable reference of this important phase of the pelican's life cycle.

Three primary breeding behaviors have been recorded by Heath's staff, with variations and combinations noted.

In courtship, the pelican's gular pouch is displayed in many variations and can be observed under the bill. The bill may be closed or slightly open, and the wings partially or fully extended. The head sway that accompanies the pouch display involves the head and the bill, which is usually open. Head-swaying follows a path that somewhat resembles the symbol of infinity, although this can vary also.

Bowing, another part of the ritual, can best be described as the neck arching away from the body with the bill pointing downward and slightly back. The wings remain folded, but slightly open from the body. Both wings jerk rhythmically and a guttural noise—a hiss—is emitted from the trachea.

Following a female's acceptance into the territory, the male selects

a twig to his liking and presents it to his new mate. Twigs are tossed into the compound by the sanctuary staff. On a few occasions a female has presented a twig to her mate. This is uncommon, but the mate will accept a twig even though he is the primary supplier of nest material. When the female does the presenting, the male displays his gular pouch with the twig held firmly in his bill. The female usually acknowledges the male's offering in the same display manner. She always sits down before placing the twig on the ground, after which more courtship behavior is displayed.

The female pelican is the primary nest builder, working each new twig offering into the nest to make it solid. Males have been observed placing a twig in the nest, but the female usually rearranges it to her liking. If the twig is as much as two to three feet in length, both birds take opposite ends of it and place it in the nest together. During courtship and nest building, both birds share equally in tending of the nest.

Nesting pairs in the same compound sometimes battle over the choicest sticks, and it is not uncommon for one pelican to snatch a stick from another's nest, leading to much bill-snapping and territorial protection. If a free-flying pelican nesting in a compound does not find a twig to its liking, he may fly out of his pen and bring one back from the outside.

Nests are built on the ground with the exception of free-flying pelicans, which in one recent year constructed seven nests in trees overhanging the sanctuary. A nest averages 60 centimeters in diameter and 18 centimeters in height. Among the monogamous pairs at the sanctuary, the nest size remains much the same season after season. Mated pairs appear to have a high percentage of monogamy. Occasionally a clutch of eggs has been laid in an indentation in the ground with a few twigs placed around it. The indentation is made by either sex by digging the dirt out with the bill and tossing it aside.

Mating occurs during territory establishment and throughout the construction of the nest, rarely after the eggs have been laid. Before mating, both birds assume a bowing position. The male then begins to mount the female and grabs her by the neck with his bill. She moves her tail feathers to one side to allow him to unite with her.

Successful mating takes anywhere from five to fifteen seconds. After the union is complete the male wiggles his tail and stands proudly next to his mate. Mating, though not always successful, has been observed as many as four or five times in one day.

The nest is tended an average of one to two weeks before the first egg is laid. During this time both male and female establish a set routine of tending the nest. This continues throughout the incubation of the eggs and varies among pairs.

The night before an egg is laid, the female sits tightly on the nest, and the male is beside it. The female does not accept any food offered to her, and her mate eats very little. During the time between the laying of each egg, the appetites of both birds return to normal. Eggs are laid at intervals of every other day.

Incubation lasts from 29 to 31 days. The average incubation of 42 closely observed eggs at the sanctuary was found to be 30.9 days. As a point of information, 13 of the second and third eggs that were laid in a total of 16 clutches hatched in less time than the first eggs laid in those clutches. Sanctuary observers believe this occurred for two reasons: the second and third eggs laid were incubated more efficiently than the first laid, and the chicks in the second and third eggs possibly heard the cries of their already-hatched siblings.

During the incubation period, the male occasionally offers a twig to his mate. Too many twigs applied to the nest may cause it to become concave; the eggs will drop and, without proper incubation, will become cold and fail to hatch. One nest at the Suncoast Seabird Sanctuary became so tall that it had to be propped up with cement blocks.

Females are the primary incubators, with the males standing or sitting beside the nest. Incubation has been observed in two different positions. In the first, the eggs are located on top of the female's feet with the belly covering them. The second has both feet covering the eggs as if standing on them. Both positions appear to be comfortable for the parent, but repositioning at intervals seems necessary for

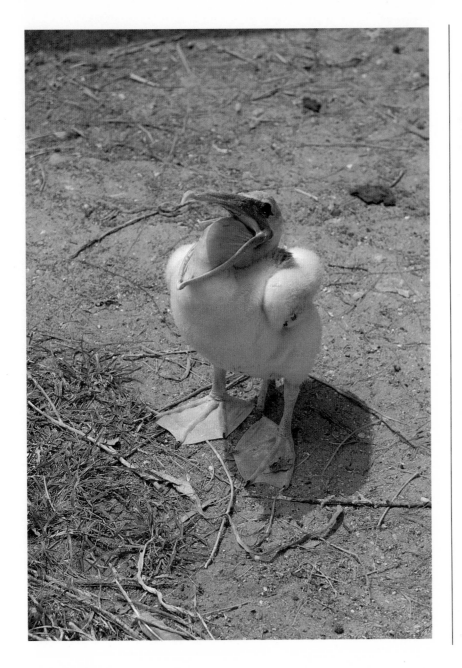

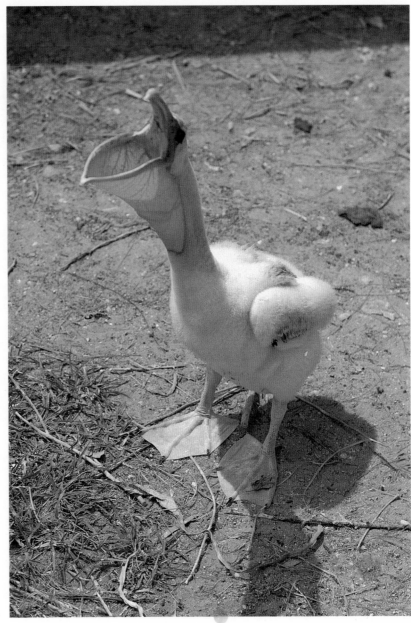

The views on pages 31–34 show baby pelicans and adults inverting the gullet, making it into a long funnel, and generally contorting the neck and pouch.

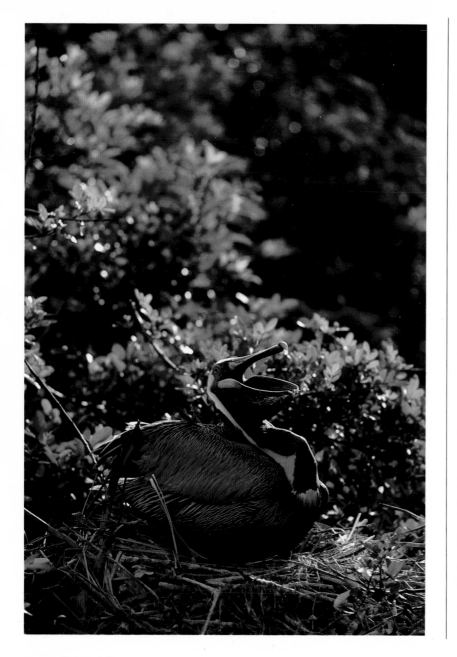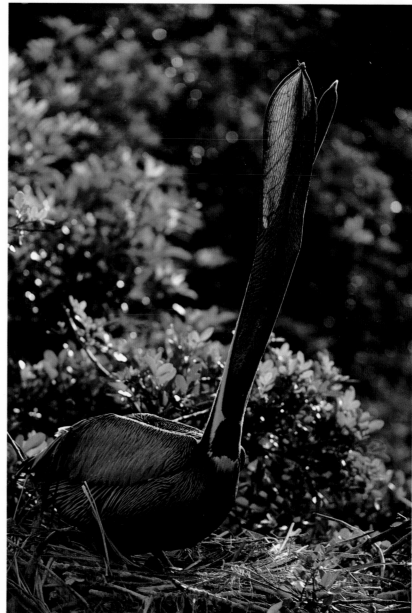

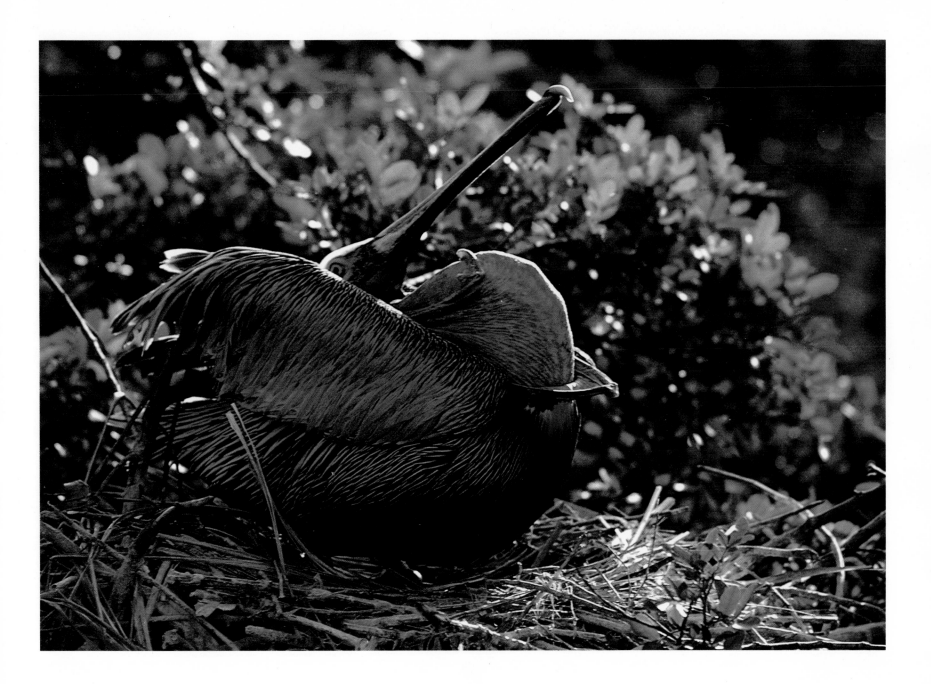

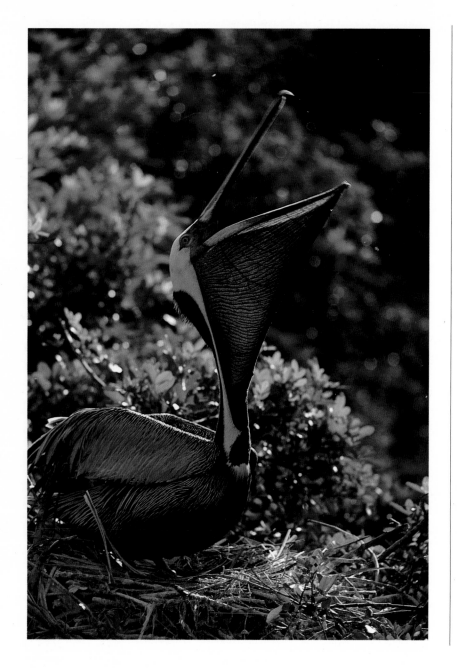

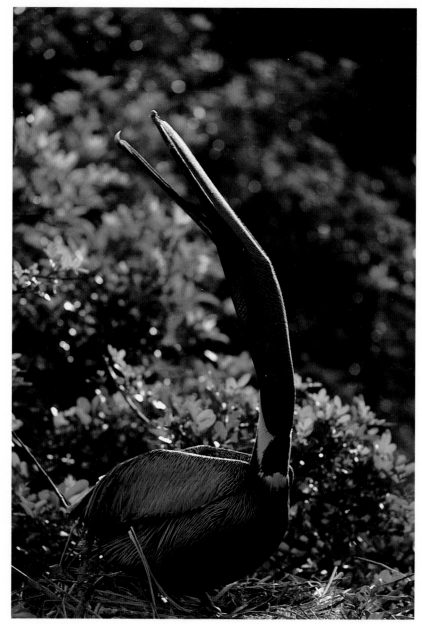

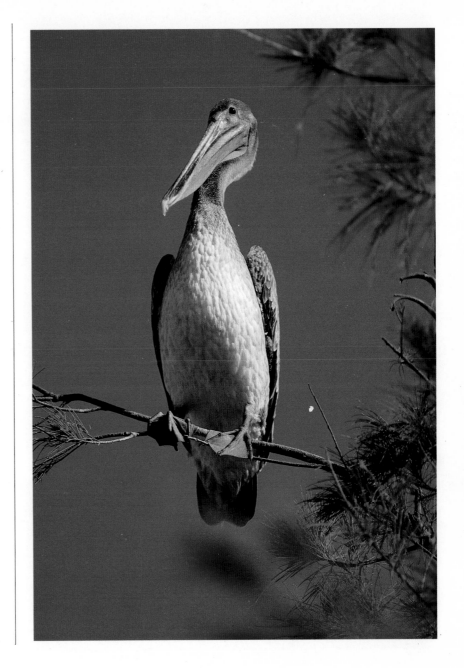

A one-year-old pelican on perch.

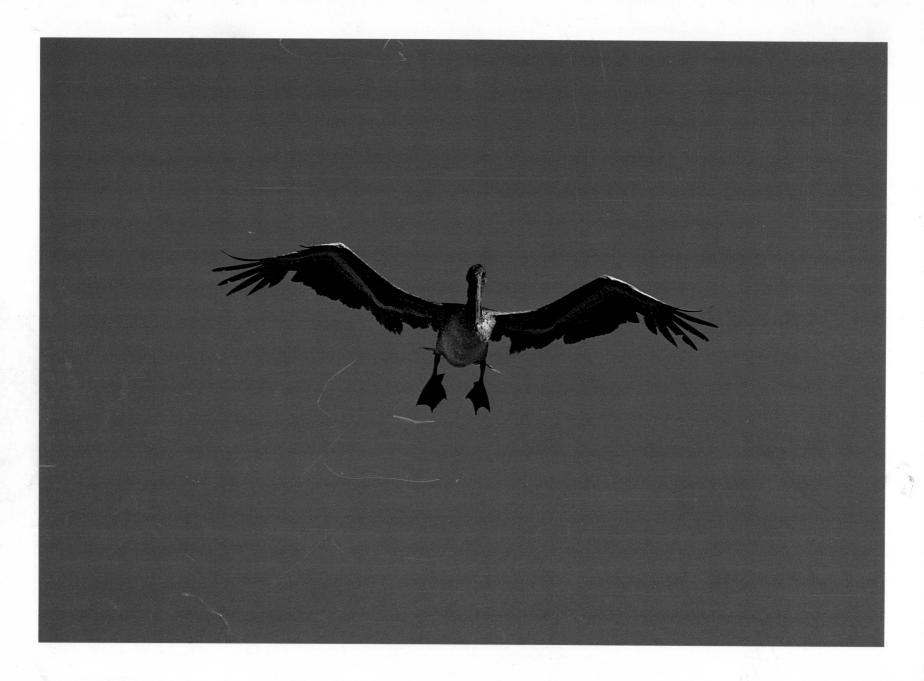

A one-year-old pelican in flight. He now has a brown head, white belly, and mostly brown mandibles.

36 *Right:* At two years, the abdomen and the head have turned brown.

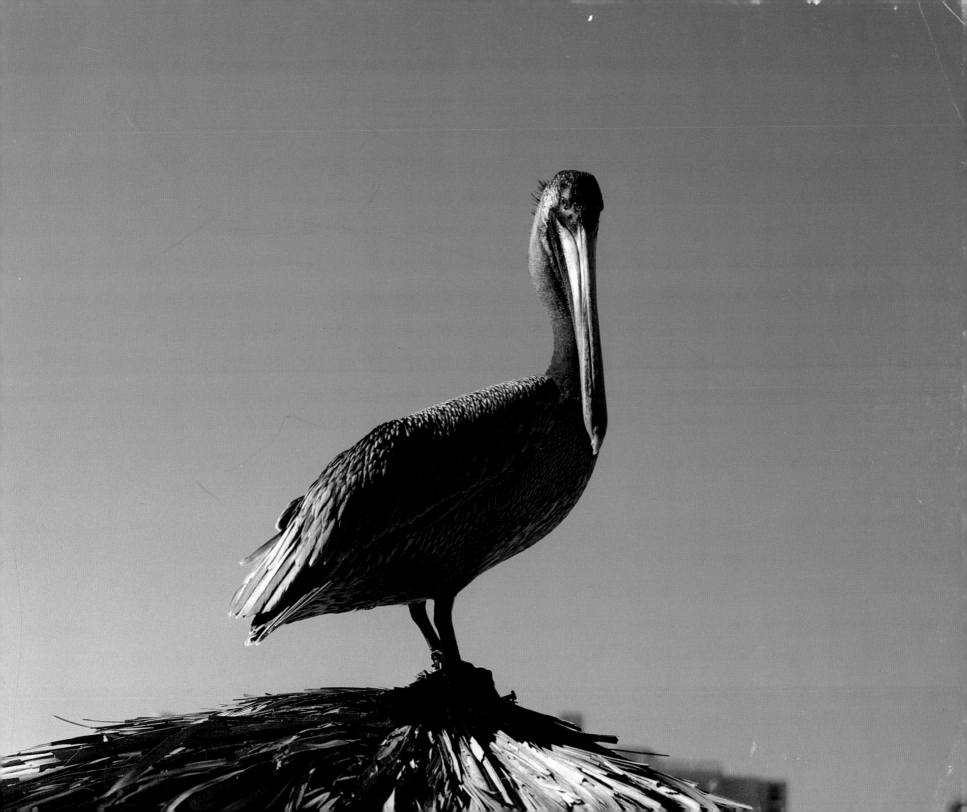

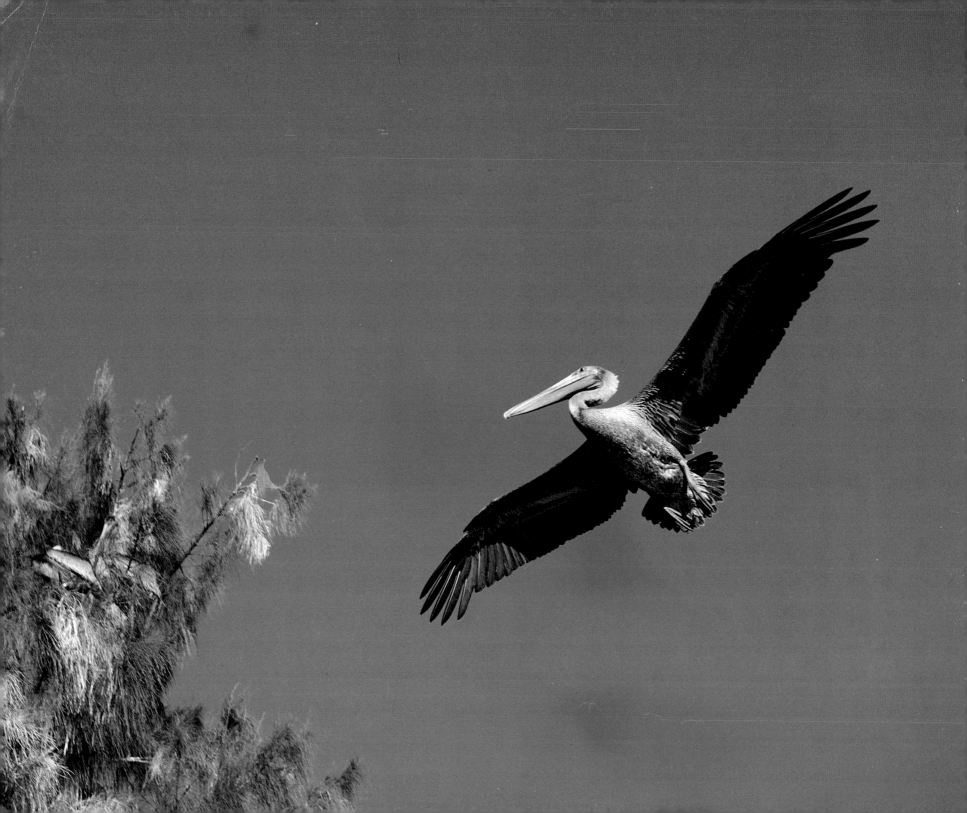

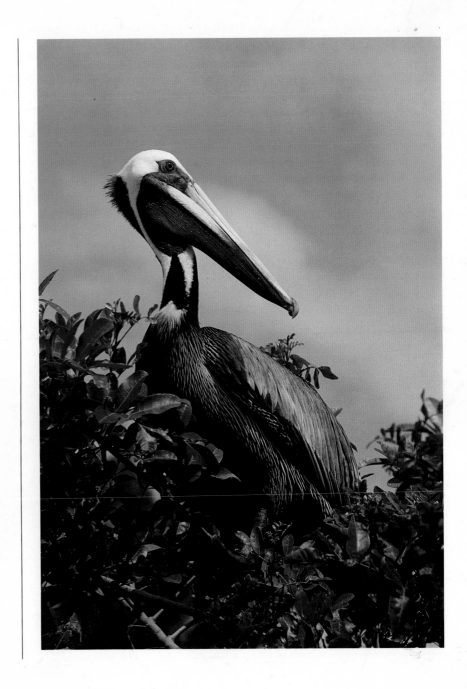

Left: A two-year-old in flight, showing the darker belly.

Right: A sexually mature bird roosts on the nest. There is white plumage on his head and neck. His body is now dark brown.

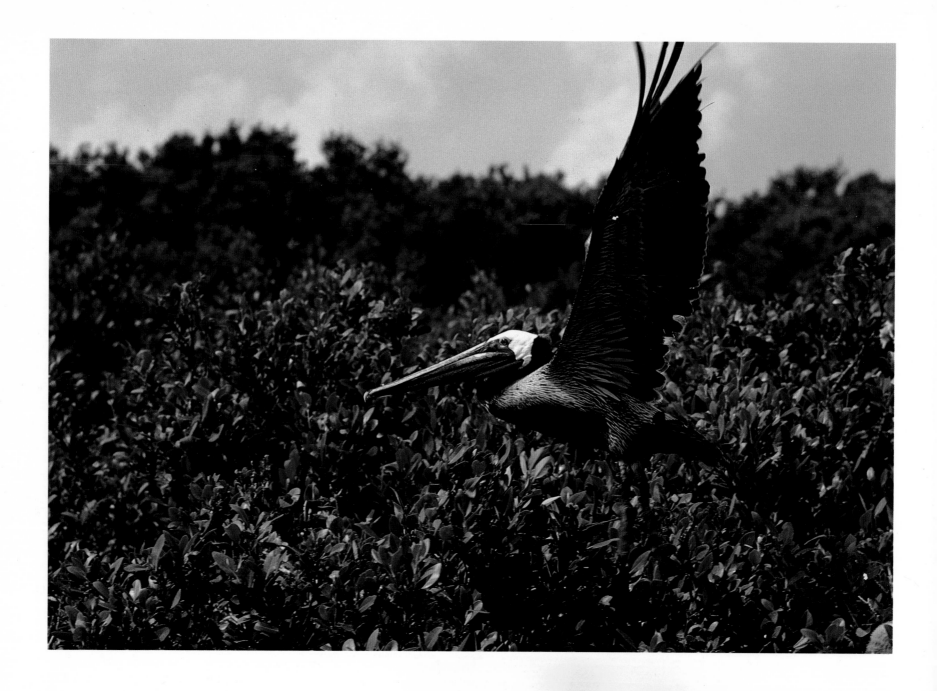

Above: In flight over the mangrove trees. **40** *Right*: This pelican reveals his full breeding plumage: gold head and pink eye.

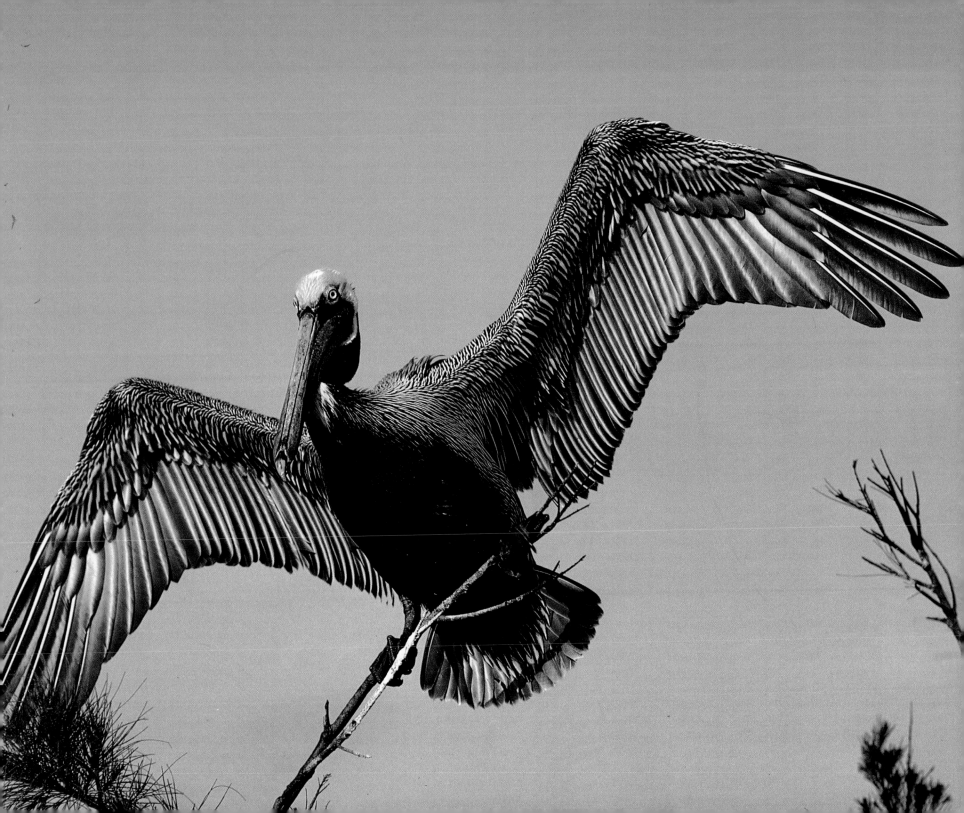

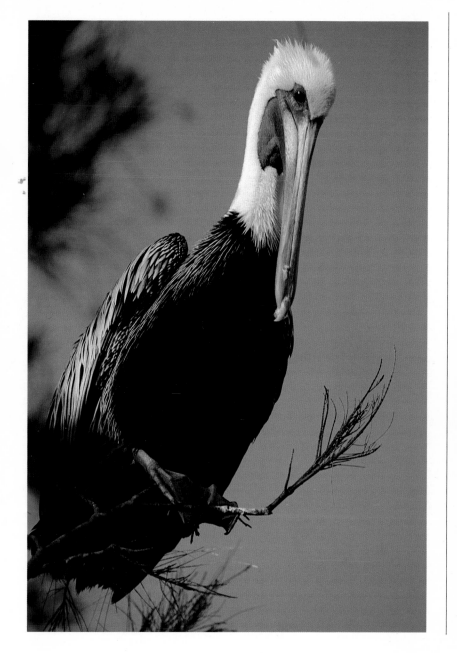

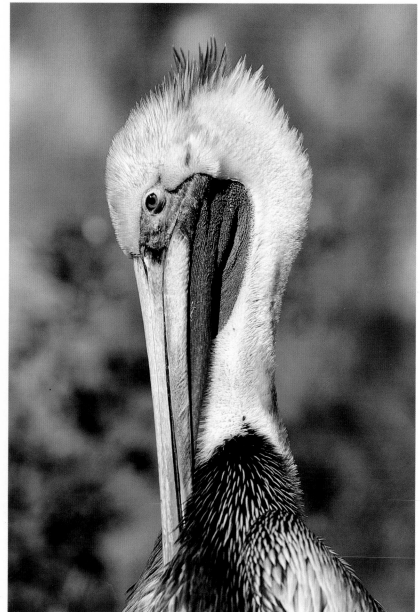

Full breeding plumage with hint of red visible in mandibles. **42** On the nest after breeding, the bird's gold plumage has faded to white.

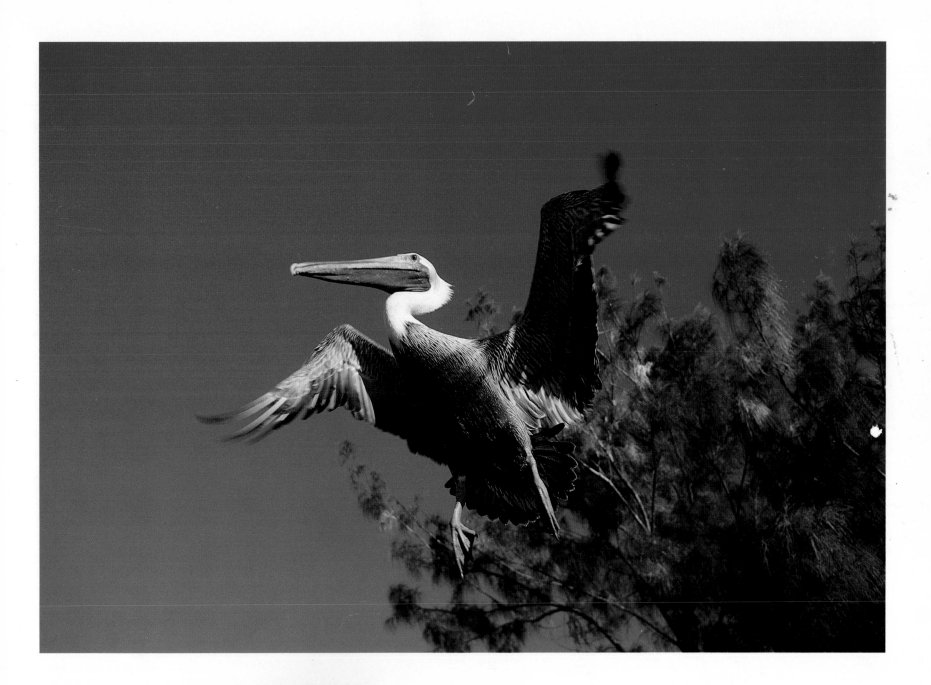

Because of its size and weight, the pelican must give many hefty flaps of its wings to become airborne.

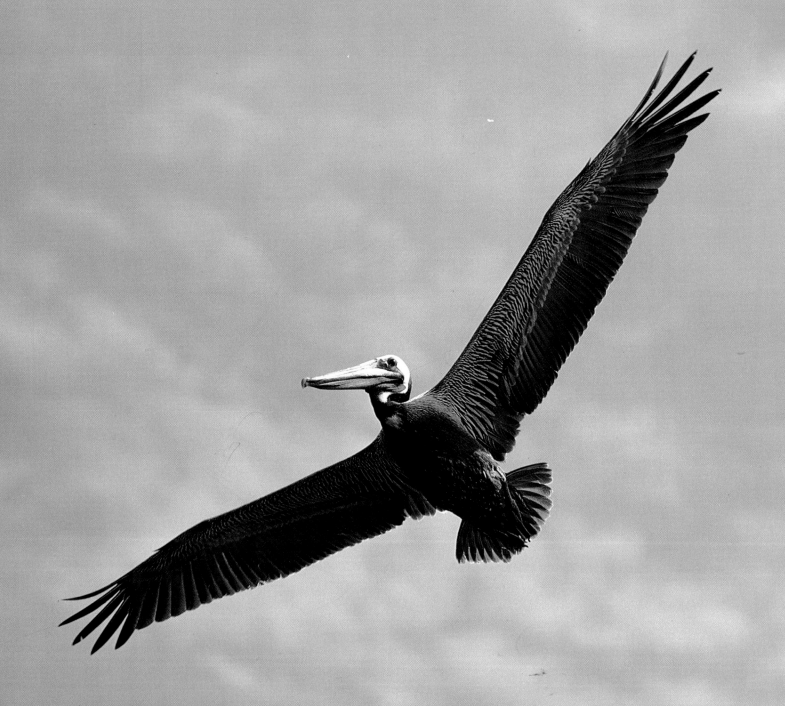

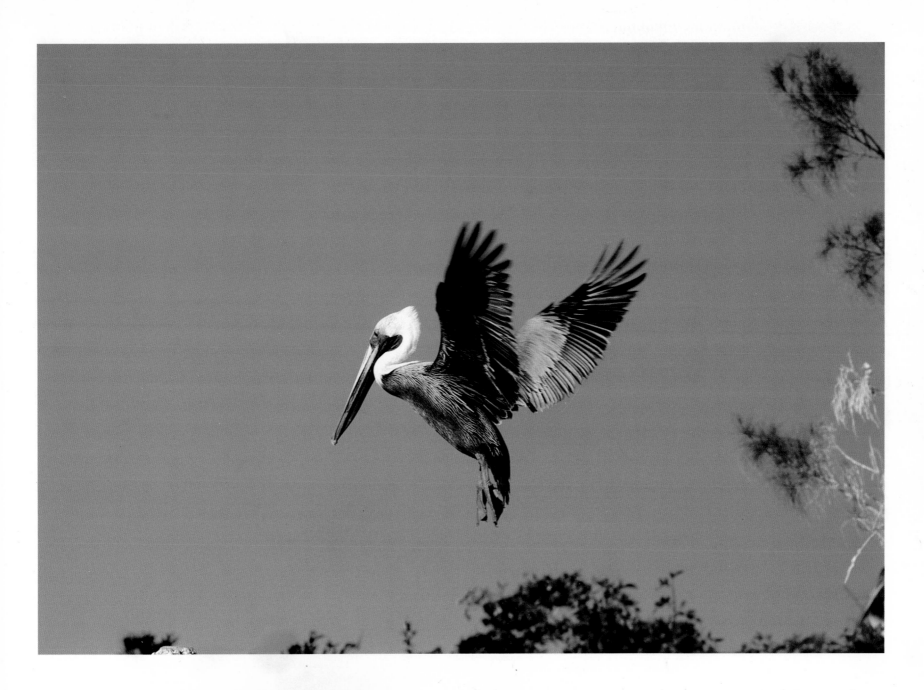

Left: After taking off, the pelican's flight seems almost effortless. Aloft the bird assumes grace and stature perhaps unexcelled by any other bird.

45

Above: The pelican lands into the wind, flaps its brown wings three or four times to brake itself, then settles to rest.

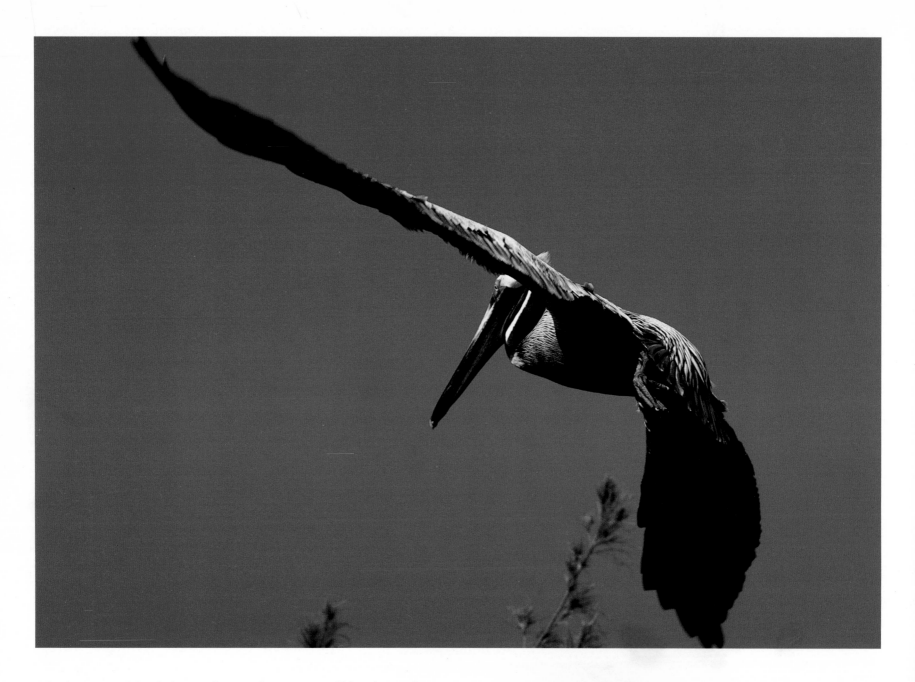

It has been reported that the brown pelican can fly a maximum of fifty miles round-trip on a fishing mission.

incubation, the female lifting her weight by pushing down with one or both wings and moving her feet. The movement may also be for comfort and egg rolling. Laying has never been observed, but presumably the eggs are laid between sunset and 10 A.M. the following day.

At Suncoast, 215 clutches of 538 eggs were laid between 1974 and 1981. March has been the most productive month; no eggs have been laid in July, and only one clutch of 3 eggs has been laid in August.

Hatching time has been known to take place in as few as 1.4 hours, and as long as 28.6 hours. The average time recorded of 41 hatching eggs was 18.5 hours. Hatching is defined as beginning at the first noted pip to the time when the chick is completely free of the egg shell. Heath stresses that this information should not be construed as hard evidence, however, since the female sits so tightly on the pipping egg that observation is difficult.

During incubation, the pelican colony has been a silent place. But as the eggs begin hatching, it erupts with sound; almost from the moment of hatching, which chicks accomplish by slowly chipping out of their shell with a tiny calcium tooth—lost a few days later—chicks are noisy creatures. They sound off with considerable peeping, squawking, screaming, and wing-flailing, which increases in tempo as they grow older. Only when a chick is asleep is it silent. Like a human newborn infant, its demands of life are quite simple: all it wants is food and sleep.

Nearly featherless when hatched, the wrinkled pelican chick resembles a piece of ugly pink meat. At this stage, its bill appears awkwardly long, and its feet disproportionately large. New chicks have little coordination and can barely lift their heads. Every effort to rise is usually followed an instant later by collapse onto the nest, with bleats and squawks, helplessness, and annoyance.

Because each chick is hatched a day or so after its predecessor, the later arrivals find themselves at a disadvantage at feeding time; being younger, they are weaker and less coordinated. When the parent regurgitates into the nest, the first chick, which is more coordinated, picks up and swallows most if not all of the fish before the second- and third-hatched. If the parent regurgitates more, the first chick may eat again before falling asleep. Only then, if there is food remaining, may the later arrivals eat. Usually there is enough food to go around; only one or two sardines are required to fulfill a new pelican chick's daily demands.

Young pelicans require more food than is necessary merely to remain alive, however. They must store up enough body fat to be able to leave their nest and face the world alone. At fledging time, pelicans receive no support or guidance beyond their own instinct.

Until they are about ten days old, pelican chicks are fed fish directly by either parent. Usually, the adult places its food on the bottom of the nest to be picked up. After ten days, however, chicks are strong enough to reach into the parent's bill and take the food on their own. Before ornithologists began closely studying the brown pelican earlier in this century, and understood what was happening, the sight of a parent pelican seemingly biting her chick's head off—her bill almost entirely enclosing its head—appeared to be a brazen act of murder. Later, they learned that by sticking its tiny head in its parent's mouth the chick was forcing regurgitation.

Parents recognize their own young, and they attempt to discourage other chicks from stealing food. Intrusion is hardly a problem in colonies where nests are built in trees, but in those where nests are at ground level, the young often wobble from nest to nest seeking a fish handout if their own parents haven't brought back a satisfying meal. Compared to a parent's own size and strength, those of the young seem miniscule. But when great numbers of small intruders begin invading a nest, the parent often has a struggle. As described by the naturalist Frank M. Chapman, the entitled young come to their parent's rescue with a spectacular lustiness.

> The parent does not, of course, always have to fight its way through a mob to feed its offspring. Often only a bird or two is to be driven off and on such occasions the rightful young assist,

the method of attack employed by [them] being thrusts of the bill from which no harm appear to follow. The actions of the rejected young bird are remarkable. With an only-son air he prances confidently up to the food-bearing adult and without so much as a by-your-leave attempts to insert his bill. When, however, he receives a blow where he expected a fish, his demonstrations of disappointment are uncontrolled. He acts like a bird demented, swinging his head from side to side, biting one wing and whirling around to bite the other in a most ludicrous manner.

During the nesting season, parent pelicans must catch enormous amounts of fish to feed themselves and their chicks. The chicks each require food totaling 30 to 40 percent of their body weight daily to reach fledgling size and to be strong and healthy enough to leave the nest. Altogether, this means the parents must find and bring back between six and nine pounds of food each day, enough for three chicks.

Dr. Ralph Schreiber conducted an experiment in Florida that proved young pelicans to have a natural ability to offset periods when fish is in short supply. For two weeks he denied all food to brown pelican chicks in captivity, which resulted in a 50 percent weight loss. Dr. Schreiber found, however, that in the face of imminent starvation, the chicks acted quite normally, and when he began feeding them again, they regained all their weight and resumed normal growth.

It is essential for chicks to maintain their body temperature; they must not become overheated or chilled. One source of cooling is the evaporation from the moist body waste, or guano, deposited by both the chicks and their parents, which coats their bodies as it dries. Chicks also cool off by gular fluttering—inhaling rapidly through their horizontally held partially open bill and using their throat pouch to move the air rapidly through sacs connected to the body organs.

Once the chicks have fledged, ten to twelve weeks after the hatching, they enter a do-or-die period of learning. Their relationship with their parents lasts less than three months, and they must learn to fly and fish entirely on their own. Few fledglings are successful at fish-diving the first time they attempt it; for many, it takes long days or even weeks of strenuous trial and error. If the parents cannot find an adequate supply of fish for their brood, the young may not be strong enough to learn to catch fish. If they cannot learn, they starve to death. Therefore, food supply is critical during the nesting season.

There are many causes for periodic "crashes" in fish populations and for the other factors that adversely affect the brown pelican. It is true that DDT and other pesticides were thought to be a factor in the drastic decline of brown pelican populations in California and to some degree along the Gulf Coast. Yet vast pelican colonies almost vanished entirely years before DDT was developed and put into use, and in at least some of these instances, the cause was traced to food shortages.

Oil pollution is another favorite target of environmentalists, both as it affects the fish and as it affects the bird directly. Yet an exhaustive study of California's Santa Barbara Channel in the wake of the 1969 Platform-A blowout and subsequent oil spill indicated that little long-lasting damage had resulted to biological populations there, including fish. True, several hundreds of water birds died in the spill, but their loss was attributed directly to becoming coated with oil and losing their ability to fly and find their food.

A more recent study, completed in 1974, offers further evidence that *routine* oil operations—exploration, drilling, and production—do not adversely affect the fragile marine ecosystem. Conducted by the Gulf Universities Research Consortium, an organization of thirteen Gulf Coast universities and research institutions, the two-year, $2 million research project was conducted in Louisiana's Timbalier Bay, site of one of the oldest and most intense oil drilling activities, and the adjacent shallow water area of the Gulf of Mexico. Despite the 171 drilling platforms in the bay (and more than 2,000 in the adjoining gulf), the marine food web was virtually unaffected. Populations

of phytoplankton and zooplankton, the tiny but abundant plant-animal organisms that form the first link in the food web, had not changed significantly in twenty years. Organisms living on the submerged oil platforms were similar to those on any other kind of artificial reef, and as such the platforms had probably attracted greater numbers and species of fish.

On the other hand, GURC scientists discovered a massive, forty-foot-thick turbid layer covering thousands of square miles sprawling westward from the Mississippi border along the Louisiana coast. Near the sea floor, the layer is low in oxygen and contains very little plant or animal life. In a preliminary report, GURC attributed the source of the turbid layer directly to the Mississippi River, whose flow into the gulf each second is an astonishing 180,000 cubic feet. Each year, this flow carries 750,000 tons of mud and sand, plus chemical wastes and other substances derived from urban and industrial sources, upriver, into the coastal Gulf of Mexico, one of the prime habitats of the brown pelican. The flow of toxic zinc alone amounts to an estimated 3.2 tons per day, at least a part of it the result of the upriver industrial discharge. The oil platforms must share some of the responsibility for the zinc; it is an accepted practice of offshore drillers to install "sacrificial" zinc plates on the legs of their steel platforms that will attract the chemical processes of corrosion to themselves and forestall damage to the costly rigs.

Just what effect the Mississippi's tremendous dumping process has on those gulf fish populations that help to keep the brown pelican alive and healthy is not known. But growing evidence from areas of brown pelican colonization indicates that nature may be as important a fish killer as man. Coastal Peru is an example. Off the coast of this South American nation is found one of the largest fisheries in the world—millions of tons of anchovies that support millions of waterbirds, including brown pelicans.

At least five times in the past fifty years, a sea-warming condition that South Americans call El Niño has decimated the anchovy population, which in turn resulted in starvation for millions of fish-feeding birds living on the coast nearby. In 1972, following the arrival of El Niño, the commercial catch of anchovies in this area dropped from 12 million to 4 million tons; not only did an estimated 15–20 million guano birds die, but Peruvian industries depending upon the anchovies—manufacturers of fish meal, for example—were nearly wiped out.

Anchovies prefer cold water. El Niño is a condition that alters the Peru Current, which normally sweeps northward along the coast; by pushing the cold current farther offshore, it diffuses and sends in warm equatorial currents that adversely affect the anchovies.

Several oceanographic research expeditions have been sent to offshore Peru to study the phenomenon, but so far there is no convincing evidence of what causes this threat to the brown pelican and its water-bird cousins.

Once fledged and entirely on his own, the young brown pelican now must face this hazard as he must face others. He has few if any natural predators; despite his benign nature, he is not hunted by raptorial birds, and only an occasional shark attack has been noted among pelicans resting on the water. Along the Gulf Coast, hurricanes, which most often occur in late summer and early fall, are a threat, though, fortunately, they occur between the important nesting seasons. Hurricanes that kill people most certainly kill pelicans.

For the fledged brown pelican, then, life is full of continuing hazards; since he has managed to survive for thirty million years or so and is today among the living birds rather than the extinct, he wears an even more remarkable mantle of importance among nature's creatures. Certainly, however, in North America his total population today is much reduced in number. And if he is to continue to survive, he must have the full cooperation and help of man.

3

Welcome Back, Grand Gosier

Stretching nearly three hundred miles east to west, as the crow flies, the Louisiana coast is one of the world's richest biotic wonderlands. The rich sediments from the Mighty Mississippi plus a dozen other significant rivers have made its waters incredibly fecund. Its five-million-acre system of estuaries and offshore shallows, marshes, and bayous is responsible for more than one-third of the nation's annual seafood catch, more than $10 million worth of fur—mostly muskrat and nutria—that account for roughly 40 percent of the country's fur industry. Its rich waters attract diverse species of water birds—some to nest, some to overwinter, and some to pause long enough during migration to build up food reserves for the long migratory flight across the Gulf of Mexico.

The greatest concentration of overwintering waterfowl in the world is found in the Louisiana wetlands from December through March. The beautiful and glamorous wading birds, including roseate spoonbills, white and white-faced ibis, great egrets, and their smaller cousins the snowy egrets, find splendid nesting sites on islands along the coast and in the bays. In recent years cattle egrets—newcomers to the New World—by the thousands have moved into some of the rookeries to nest. Also, great colonies of great blue herons and Louisiana herons and little blue herons and night herons can be found in lesser numbers. On many sand beaches, sandbars, or shell bars, colonial nesting terns, including the royal, the sandwich, and the least, nest successfully year after year. One colony of sandwich terns alone numbers over 30,000 pairs.

There are nesting colonies of laughing gulls almost too numerous to count. And the most elegant flier of them all, the black skimmer, probably nests more successfully in the Louisiana wetlands than

in any state along the Gulf of Mexico. The Louisiana wetlands are home, either full or part time, to literally millions of birds. A flight in a light plane over the marshes on any fine day, summer or winter, will reveal a wealth of birdlife as great as any wetlands in the world. Around the middle of the 1930s such an airplane ride, especially along the marshy coast, would have revealed additional thousands upon thousands of brown pelicans.

Depending on the season of the year, these remarkable birds would be found diving for fish and roosting on sandbars or in great nesting colonies. A similar trip during the mid-1960s would have produced an altogether different picture. Most of the bird species listed above would have been found in approximately the same numbers, but one species would be conspicuous by its absence—the brown pelican. What happened to the brown pelican?

The brown pelican, which Audubon studied and painted, which Cajuns affectionately nicknamed *grand gosier*, and which, because of its ubiquitous presence throughout Louisiana's coastal region, was designated the state bird, had simply disappeared. The last nesting effort apparently had taken place in 1961 when at North Island, about seventy miles due east of New Orleans, 100 nests were counted on May 21 (J. Valentine), increasing to 150 nests by June 6 (J. Walther, J. Valentine, and R. Andrews). In 1962 only six adults and no nests were found on June 6, 7, and 9 (L. F. Williams, S. G. Clawson). For all intents and purposes, the state bird was no more in Louisiana.

The recorded history of the brown pelican in Louisiana is very fragmented. For the most part we have nothing but casual observations regarding their numbers. The major breeding rookeries at Raccoon Point at the western end of Isles Dernieres, East Timbalier Island, the mud lumps near Pass a Loutre at the mouth of the Mississippi, Grand Gosier Island in the Chandeleur chain, and North Island along with Isle au Pitre west of the north end of the Chandeleur chain were visited occasionally by ornithologists. A few isolated counts of the nesting birds had been made, one of the earliest recorded by Herbert K. Job (as quoted in *Birds of America*). Job

writes, "On June 21, 1915, I visited a great colony of ten or twelve thousand breeding [pelicans] on East Timbalier Island, on the west coast of Louisiana, this also being a government reservation. Although it was late in the season, the Pelicans had just laid their eggs and not one had yet hatched. The nests were all on the sand of the low island. Their lateness may have been due to robbery or disaster elsewhere earlier in the season. At any rate, they were too late for the young to mature before a terrible tropical hurricane visited the coast in August and every one of the thousands of young birds on the island perished." Job went on to say, "Surely the birds have enough to contend with without having man as an enemy."

Harry C. Oberholser (*Bird Life of Louisiana*, 1938) recorded some 11,500 breeding birds in fewer than six colonies in 1933. There are no reports for the 1940s. George H. Lowery, Jr., in his 1974 edition of *Louisiana Birds*, summarized the 1950 data (all from North Island) in one short paragraph: May, 1957: well over a thousand nests (Robert J. Newman and P. A. Daigre); June 7, 1958: thousands of adults, as well as young of all ages (W. J. Turcotte and others); 1959: no report.

In the spring of 1958 the Mississippi Ornithological Society took a field trip to the Chandeleur Islands, the chain that seems to form a parenthesis around the easternmost marshes of Louisiana. Ethel Floyd of Gulfport, president of the society was there with her husband, Dr. Bedford Floyd, a prominent Mississippi Gulf Coast surgeon. Ethel Floyd remembers the occasion well. Fifteen members took an overnight boat trip; they anchored a few hundred feet off North Island where several in the party waded ashore to observe and photograph the pelican colony. Ethel Floyd recalls that she was interested only in photographing the birds. There were hundreds of fledglings in the shallow waters around the island, and it seemed that every mangrove had an active nest in which could be found eggs, hatchlings, or nestlings. The mangroves were little more than shrubs, three to four feet tall. When questioned about the number of nests, Mrs. Floyd thought that *thousands* might be an appropriate re-

sponse. She suggested a call to Dr. Henry Haberyan, who was also on the trip and who took, as she recalled, very detailed notes on the colony. A subsequent call to Dr. Haberyan confirmed that he had indeed recorded the number of nests but that he had given the notes away when he moved to North Carolina. Although unable to remember the exact number of nests he had counted, Dr. Haberyan was certain that there were several *hundreds* and not *thousands.*

John Lynch, a biologist, now retired, with the U.S. Fish and Wildlife Service, was transferred to Louisiana in 1937. His job was to supervise the newly established wildlife refuges adjacent to the Gulf of Mexico, from the Florida Keys to Brownsville, Texas. At one time or another he has visited all the major pelican nesting sites. When asked about the numbers of brown pelicans he had seen during his early years in Louisiana, he would only say that he "wasn't counting and neither was anyone else." He will say that they were there by the thousands, and he remembers vividly a visit to the mud lumps shortly after his arrival, when one of the unique little islands had so many nests on it that it was almost impossible to step ashore without trampling them. Before he learned to fly, the Coast Guard out of Biloxi provided John Lynch with hundreds of flying hours on wildlife surveys.

After he learned to fly, back in the 1940s, he spent more hundreds of hours flying over the Louisiana marshes. He is certain that the pelicans were on the decline throughout the forties and fifties. Nesting on the mud lumps was very much reduced during the 1950s, probably because erosion had reduced these interesting geological structures from an elevation of as much as eight feet above sea level to less than three feet above sea level. During high tides most of the mud lumps were almost completely submerged, and the pelicans had to move elsewhere. John Lynch does not know where they went.

Allan Ensminger, currently chief of the fur and refuge division for the Department of Louisiana Wildlife and Fisheries, came to the department in 1954. Like most of the supervisory personnel in this organization, he is an excellent pilot, and he remembers flying the wetlands during the mid 1950s, when the pelicans were present in substantial numbers.

During the winter of 1951 the temperatures stayed below freezing for seven days. Tremendous stands of the black mangrove (*Avicennia nitida*) were wiped out, nothing but skeletons remaining. A tropical plant, the black mangrove's range in Louisiana overlaps the range of the brown pelican, a tropical bird. Ensminger did not record what the cold winter did to the brown pelican. However, there were several pelican die-offs during the 1950s. In 1956 T. A. Imhof and party noted 20 to 25 dead pelicans, during a three-day period, between Dauphin and Petit Bois islands in Alabama and Mississippi respectively. On July 1 in the same year Mr. and Mrs. H. A. J. Evans counted 50 dead on Isle au Pitre and found others in the Chandeleurs. In 1959 Ensminger flew out to Pass a Loutre and to one of the mud lumps in the vicinity. He found many dead pelicans on the mud lump, and there were dozens of dead gulls and terns as well. Again in 1960 Ensminger found numbers of dead pelicans during a visit to the mud lumps. There had been a massive fish kill that year, and pesticides were definitely implicated.

Unfortunately, during the period of pelican decline no chemical analyses of eggs or tissue were made, so the cause of death is not known. However, 1943 to 1963 had been a time of ever-increasing use of agricultural pesticides in the Mississippi Valley. Cotton is grown from southern Missouri to the Gulf of Mexico and from Texas to Florida. No other agricultural crop is as vulnerable to insect damage, and no other agricultural crop receives as high dosages of pesticide. From the time cotton starts fruiting, it is the custom in the Mississippi Delta to apply insecticide, usually by air, on a weekly basis. This aerial bombardment usually continues from June through September.

Several millions of pounds of DDT were applied each year in the Mississippi Delta alone. Aldrin, dieldrin, endrin, chlorodane, BHC, and toxophene were used by the millions of pounds annually. Unlike DDT, these chlorinated hydrocarbons are toxic to warm-blooded ani-

mals. The Mississippi River, flowing into the Gulf of Mexico through the various passes, must certainly have discharged a weak solution of varied potent agricultural chemicals. In spite of this, shell-thinning and consequent reproductive failure have never been implicated in the demise of the Louisiana brown pelican (Lowery, *Louisiana Birds*, 1974).

Significant die-offs of fish were noted along the Mississippi and Atchafalaya rivers in the 1950s and 1960s. During the same period, hardly a year went by without a fish die-off in one or another of the dozens of oxbow lakes paralleling the Mississippi. Some of these were eventually attributed to high levels of certain chlorinated hydrocarbons. In 1961, two years after the demise of the last Louisiana brown pelican, there was a massive accidental spill of the chemical endrin into the Wolf River at Memphis. This subsequently flowed into the Mississippi and killed fish all the way down to the Gulf of Mexico. It is estimated that over five million fish died in this one tragic accident. Lowery (*Louisiana Birds*, 1974) suggests that "the disappearance of our Brown Pelicans seems not to have been a prolonged process brought about primarily by reduced fertility of weak-shelled eggs. . . . The swiftness of the population collapse points to a direct die-off of adult birds."

From 1971 on, eggs have been removed annually from pelican nests at Grand Terre and sent to the U.S. Fish and Wildlife Service laboratory at Patuxent, Maryland. Here, Lawrence J. Blus has analyzed them for shell thickness and pesticide residues. Although egg-shells from the introduced colony were found to be from 6.7 to 13.5 percent thinner than museum eggs collected prior to 1947, Blus concluded that the loss of eggs was "not high enough to interfere with reproductive success."

Concerning the "demise of the original brown pelican population in Louisiana," Blus concludes that the "apparent sensitivity of the brown pelican to endrin in the 1975 die-off and high levels of endrin in biota in Louisiana estuaries at the time of extirpation strongly suggests that endrin was the major factor, acting primarily through direct toxicity to the pelican and perhaps secondarily through food shortage as a result of short-term reductions in prey fish populations."

During the 1940s, oil in significant quantities was found in the Louisiana wetlands. West of the Mississippi River, Timbalier and Barataria bays received a great deal of attention from drillers. Islands in both these bodies of water had been the traditional nesting sites for large colonies of brown pelicans. What happened when the oil rigs moved in is simply not known; apparently very little, since with this kind of activity a die-off would surely have been noticed. Perhaps oil rigs and pelicans can coexist. The recently established colony on Queen Bess Island in Barataria Bay has flourished almost in the shadow of oil rigs. A visit to the island during peak nesting revealed a working rig only a mile or so from the colony. The Audubon Refuge near Marsh Island, eighty miles west of Queen Bess, has oil wells on it and is ringed by wells and rigs.

Could the weather have played a part in the demise of the Louisiana brown pelican? John Lynch thinks it could and did. To quote Lynch, "The brown pelican is obviously a tropical bird and so is the roseate spoonbill, and it does the same thing as the brown pelican. In southwest Louisiana our roseate spoonbills build up for ten years and then whap! Too many of them try to overwinter instead of migrating. They do not make it, and the same thing happens to the reddish egret—clearly a tropical species."

Lynch has studied weather records in conjunction with some research on tropical orchids growing in southern Louisiana. The six coldest winters on record in this area are:

1899	64 consecutive freezing hours
1918	44 consecutive freezing hours
1940	42 consecutive freezing hours; 18 consecutive freezing nights
1951	54 consecutive freezing hours; 7 consecutive freezing nights
1962	62 consecutive freezing hours

Lynch was studying woodcock in 1940, and during the cold snap he noted that these birds were pushed all the way into the marshes, searching for ground soft enough to probe.

In 1947 a severe hurricane struck the Louisiana coast. By 1955 hurricanes were being given feminine names, and Flossie visited the wetlands with devastating results. Audrey was no lady; five hundred people lost their lives in Cameron, Louisiana, when she struck in 1957. What happened to the pelicans during the severe winters and hurricanes? Lynch suggests that the brown pelican, operating at the extreme northern edge of its range, is quite vulnerable. During cold winter months the bait fish on which the birds feed move into deeper waters and out of range of a diving pelican. If a cold spell lasts long enough, the birds use up their reserves of stored energy and, to quote Lynch, "you slam the door and they die." The door that slammed could have been famine, pestilence, pesticides, hurricanes, or all four.

(In connection with the above, John Lynch tells an interesting anecdote: During the severe winter of 1940, he and some of his colleagues were backing a boat out of the dock at the Lacassine Refuge when a starved pelican landed on the stern and tried to eat the flag. Lynch suggested that they catch some mullet and feed the bird. Half a dozen casts with a net produced no fish so they moved into deeper water where the only fish they caught were catfish. Since pelicans will not eat catfish because of the sharp spines, the men removed the spines from the fish and fed several to the pelican.)

Dr. Leslie L. Glasgow took over the directorship of the Louisiana Wildlife and Fisheries Commission in August of 1966, when Louisiana's state bird had been missing from the coastal region for five years. Dr. Glasgow had discussed the possibility of initiating a pelican study and reintroduction program with some of his associates on the commission. He had also been in touch with Alexander Sprunt, research director with the National Audubon Society, stationed in Tav-

ernier, Florida. In October, 1967, he wrote Sprunt, "We are interested in exploring the possibility of restoring our state bird, the brown pelican, as a breeding species. So far we have done nothing except talk. Therefore, I welcome the opportunity of inviting a group of specialists to the state to assist with this problem." This and subsequent correspondence produced a meeting at the Rockefeller Refuge on January 16–18, 1968, that was attended by twenty-four scientists. The committee, which called itself, simply, the Pelican Committee published a memorandum on January 22, outlining seven objectives.

Only the sixth and seventh objectives are relevant here. The sixth recommended the establishment of an experimental captive colony "with the view to reintroduction of the birds to areas where they had been extirpated"; the seventh concerned the restocking of former nesting areas. This subcommittee was composed of John Lynch of U.S. Fish and Wildlife Service, Lafayette, Louisiana; and Charles R. Shaw, Department of Louisiana Wildlife and Fisheries. They were asked to work out the details of these objectives "in cooperation with Louisiana officials."

Ted Joanen, biologist with the fur and refuge division of the Department of Louisiana Wildlife and Fisheries, stationed at the Rockefeller Refuge, was appointed research leader. In June, 1969, he and five aides, biologists Larry McNease, Howard Dupuie, Davidson A. Neal, Larry Scurieux, and Tommy Prickett, traveled by truck to Cocoa Beach, a small town on Florida's Atlantic coast, not far from the Kennedy Space Center. The thriving brown pelican colony on nearby Merritt Island was their destination. Here they hoped to capture fifty fledgling pelicans as the nucleus of Louisiana's new resident colony. Helped by personnel from the Florida Game and Freshwater Fish Commission, they achieved their goal in one day on the island.

"The young birds were ideal for our purposes," Joanen recalls. "At nine-to-twelve weeks old, they were only partially fledged; although they could feed themselves, they had not yet learned to fly, so they were fairly easy to catch. When young, pelicans have very soft man-

dibles (bills). They'll snap at you, but they can't hurt too much. We had learned from experience to leave older birds alone; they can give you a very painful bite."

Transporting the young birds back to Louisiana, Joanen's group held them under captive conditions at the Rockefeller Refuge for two months and then released them at two locations. Of the twenty-five, fifteen were released as free-flyers and ten wing-clipped pelicans were turned loose in September, 1968, at Grand Terre Island, a low-lying mangrove-covered shell bar just east of the tip of Louisiana's Grand Isle. "By wing-clipping some of the birds," Joanen explains, "we hoped that the free-flying birds would be encouraged to remain in the area."

The plan worked. Ranging out many miles to feed, the flying pelicans returned each day to join the flightless flock that was enjoying mullet, croaker, and shad provided for them by their human captors.

A month later, in October, 1968, Joanen released a second flock at the Rockefeller Refuge. Fifteen were free-flyers, the rest were wing-clipped. Like the Grand Terre flock, the birds fed both on fish they found themselves and those that were spread out for them by the Pelican Committee.

For Joanen and his fellow biologists, the months ahead held news both bad and good. The Rockefeller flock fared well until the following March, when, as the refuge was hit by severe and prolonged storms, bird after bird was found to be either dead or dying at the feeding sites. Within a month, all twenty-one were dead.

On Grand Terre, 160 miles east of the Rockefeller Refuge, the outcome was far more encouraging. The pelican colony here was flourishing. To his colleagues, Joanen posed the obvious question: Since all the experimental birds came from the same Florida colony, were approximately equal in age, weight, and physical characteristics, and had been handled under similar conditions, why had the Grand Terre birds survived while the Rockefeller flock perished?

Seeking an answer, Joanen took the dead Rockefeller birds to the Veterinary Science Department at Louisiana State University and asked for postmortem examinations. At first, nothing exceptional was found. The intestinal tracts of the birds were found to contain ascarid endoparasites (round worms), which, because this routinely occurs in wild populations of pelicans, was not considered abnormal. Another finding intrigued them. The birds were also found to be badly emaciated. Apparently the rugged winter months had made it difficult for the birds to feed, and they had severely depleted their energy reserves. (It is noteworthy that during severe winters in Florida there is a significant die-off, mostly of young birds. For the past several years an ongoing Feed the Pelican campaign has functioned in the St. Petersburg area, which provides hundreds of pounds of fish each day to hundreds, if not thousands, of brown pelicans; but more about that later.)

The pelican specimens next were turned over to LSU's Feed and Fertilizer Laboratory for further examination; Joanen asked specifically for analyses that would determine the presence of any chlorinated hydrocarbon insecticide residues. Here the focus of the problem began to narrow. In the brains, livers, and other vital organs of the dead birds, high concentrations of DDE, a metabolite of DDT, dieldrin were found. Scientists then compared the tissues of the Rockefeller birds with those of healthy pelicans from Cocoa Beach and Grand Terre. The concentrations were much higher in the Rockefeller birds than in the others. As further clues in the mounting evidence, Joanen recalled that tests performed on the same Rockefeller flock—but before its release in October, 1968—indicated lower levels of chlorinated hydrocarbon residue than after they had died.

"From the tests, we theorized that while the level of chlorinated hydrocarbons in the Rockefeller birds was within tolerance limits— levels not high enough themselves to kill them—it was nevertheless high enough to so weaken them that they became unable to cope with other hazards, such as diseases and predators," Joanen says.

Joanen next sought the source of the damaging chlorinated hydro-

carbons. First he collected samples from wild fish populations of the Rockefeller Refuge. Next he gathered water and soil samples and other fish-eating birds such as cormorants and gulls that have the same feeding habits as pelicans.

Joanen now believes that pelicans had been feeding on these fish and over a period of time had ingested enough poisonous insecticides to kill severely weakened birds. The effect is analogous to an armed, very sensitive bomb. As long as the bomb is not jarred, it will remain harmless. But if it is jiggled, even the slightest bit, it will explode.

"We now believe that when pelicans are unable to feed because of bad weather, or if they are placed under some kind of stress, they begin to metabolize—live off of—their body fat," Joanen continues. "When this occurs, insecticide residues enter the bloodstream and reach vital organs. As a screening organ the liver naturally accumulates the highest levels of insecticides, but the brain and other organs are also affected. During this period of stress, there was enough organochlorine residue in the birds' system to cause mortality. Or it would so weaken the birds that they would be unable to combat stress factors: weather and predators."

Again in 1969 a trip was made to Merritt Island where fifty-five fledgling brown pelicans were collected and transferred to Louisiana. This time twenty-five of the young birds were taken to the Rockefeller Refuge and the remaining thirty released at Grand Terre. At the Rockefeller Refuge all the introduced birds perished before the winter was over (Lynch points out that western Louisiana was never a significant nesting area for the brown pelican—winter temperatures being several degrees colder here than at the more eastern Grand Terre), whereas the Grand Terre birds did well.

From 1970 through 1976 significant releases were made at Grand Terre—the number of fledglings transplanted averaging one hundred birds per year. And each year, the same procedure as in 1968 was followed: after being leg-banded with a U.S. Fish and Wildlife Service band, they were released on a pond in the vicinity of the Grand Terre Marine Research Laboratory. Daily, Joanen and volunteers

backed a tractor and trailer up to the pond and dumped out trawl remnant fish until they determined that the young birds could fend for themselves. After learning to fly, the pelicans began fishing on their own in Barataria Bay, close to the release site; they also gobbled up trash fish dumped by commercial boats returning to port.

Joanen and his group, meanwhile, were learning that because of the sensitive nature of their charges, the care and feeding of young pelicans require both experience and experimentation. When they found one batch too young to feed itself, for instance, the biologists tried hand-feeding them with small fish. But the young fledglings became so excited and frightened that they quickly regurgitated the food. Weak from lack of nourishment, several fell ill and died.

Joanen was not discouraged, and he worked quickly to save the rest. Mixing a combination of canned cat food with water to form a slurry, the biologists hand-held the hungry birds, forced open their mandibles, and poured the concoction down their throats. "We were happy to find," Joanen remembers, "that because the slurry was more liquified than the fish we had tried to feed them, it went down easily, and the birds did not regurgitate it as easily." With antibiotics later added to their food, the sick birds recovered their health and soon were fishing on their own with the healthier members of their flock.

In subsequent years, Joanen was to learn, too, that there is an age that is right for capturing young pelicans and an age that is not. On one occasion his team arrived in Florida a few days later than they had planned; the fledglings had learned not only to eat but to fly as well. Unable to catch the birds, the men planned, instead, to surprise them. Crouching low beneath their mangrove tree roosts, they waited patiently for the fledglings to return to rest. Then, on signal, they quickly reached up to grab the unwary birds.

"There's a big difference in the strength of a pelican before he flies and eats and *after*," Joanen recalls now, with bemused chagrin. "We returned to Louisiana looking like we'd been fighting with a roll of barbed wire."

As Louisiana followed the experiment anxiously, the Grand Terre

birds continued to thrive, if precariously. As they matured, they became more and more adept at fishing, and soon it appeared that they had adapted well to their new environment. But the acid test was still to come; Joanen's group, watching like anxious grandparents, silently asked themselves the same question: Would the pelicans breed in their new home?

One morning in late November, 1971, they received their answer. The pelicans were nesting on Camp Island, a very small shell reef a short distance from Grand Terre Island. Unfortunately, the first nesting effort was wiped out by high tides. Camp Island at its highest was not more than three feet above sea level—it has since been leveled by a series of winter storms, with most of the island now totally submerged—so that the combination of a strong wind and a high tide would regularly sweep over the island. The second nesting effort was also wiped out by high tides. Finally, a series of thirteen nests was constructed on the highest ridge on the island where twenty eggs were laid. The next several weeks produced apparently moderate winds and tides so that eight brown pelicans were fledged, the first in Louisiana in ten years.

It was obvious to Joanen and the biologists at the Grand Terre Marine Biological Station that Camp Island was an unsatisfactory place for the brown pelicans to nest. It was not so obvious to the pelicans. They attempted to nest on Camp Island again in 1972. Again, high tides took a heavy toll of eggs, hatchlings, and nestlings. This was a real tragedy, because several dozen eggs had been laid, and most had hatched when the high water wiped out the nesting effort. A second and third nesting effort resulted in fourteen fledglings in 1972. When, in 1973, the pelicans again attempted to nest on Camp Island, everything possible was done to discourage them. Wires were strung up, aluminum pie plates were hung on the wires, and personnel from the biological station would appear from time to time to try to scare the adult birds away from the island—all this with partial success. Some of the pelicans moved over to Queen Bess

Island, although not in the most satisfactory location. A total of twenty-six birds fledged.

The year 1974 was a good one for the brown pelicans in Barataria Bay. Although they still had not learned to nest in the mangroves or on high ground at Queen Bess, the elements were kind to them, and 104 were fledged.

A completely unexpected disaster occurred in 1975. In early March the bodies of about 100 white pelicans were found in the coastal regions of Louisiana, but they bore no marks of external abuse, and the cause of death was not readily apparent. The closely related migratory species overwinters in the Gulf of Mexico and along the coast of Central America, but nest on lakes in the northwestern states as well as in much of western Canada. (There is one small colony that nests in the Laguna Madre, near Corpus Christi, Texas, and an even smaller colony—the most northerly colony of nesting white pelicans in the world—that nests on an island in the Slave River in the Northwest Territories).

Carcasses of two of the dead birds found near the mouth of the Mississippi River were sent to Louisiana State University for analysis. The findings: high concentrations of round worms in the digestive tracts, along with relatively high concentrations of chlorinated hydrocarbons.

Was either the cause of death? Not directly, suggested J. Burton Angelle, then director of the Department of Louisiana Wildlife and Fisheries. Instead, he said, "the stress of migration, coupled with the pesticide concentrations and round-worm infestations apparently were to blame."

The die-off apparently occurred over a short period of time. All birds were found in the same stage of decomposition. Parts per million found in the brain of one male pelican were typical: 11.7 ppm PCB; not more than 1.38 ppm DDE; 1.17 ppm dieldrin; and 0.70 ppm endrin.

The brown pelican population was not affected in the spring die-

off, a fact that Ted Joanen and his colleagues noted with cautious optimism. Four months later, that optimism vanished. In a mid-1975 check of the brown pelican's total population in the state, Joanen and Angelle discovered to their alarm that almost 25 percent had vanished. The number of introduced birds had plummeted from about 450 to only 350. A few dead birds were located and their carcasses sent to LSU for lab analysis. Angelle reported that the tests disclosed the presence of at least *eight* pesticides or pesticide residues in the brain tissues.

The chemicals, all chlorinated hydrocarbons used extensively to kill pests, were endrin, dieldrin, toxaphene, DDI, BHC (benzene hexachloride), HCB (chlorobenzene), PCB (polychlorinated-biphenylys), and heptachlor epoxide.

"All of the birds tested contained what we regard as lethal doses of endrin," Angelle noted in a press release issued from his office in early July. Until the latest die-off, he explained, the annual reproduction rate of brown pelicans equaled natural mortality, thereby maintaining a fairly stable population level. "We have ample evidence," Angelle said, "that much of the endrin is coming down the Mississippi River from states north of Louisiana." The die-off was a setback, a disappointment, Angelle said, but he vowed that Project Pelican would continue. "We're discouraged, but we haven't given up."

Nesting during the 1975–1977 seasons was one disaster after another, culminating in only one bird being fledged in 1977. The reason was always the same. The nests were being built on low areas of the island where high tides—regular events in the winter and spring—would sweep over them routinely. At long last, in 1978, the birds seemed to be getting the message; they moved to the highest end of the island, where they built many of the nests on the black mangrove trees—little more than shrubs in Louisiana—several feet above sea level. This put an end to most of the havoc wrought by high water. The next five years produced increasing numbers of fledglings year

by year. In 1978 a total of 128 were fledged. There was an arithmetic growth in each succeeding year, reaching a total of 430 in 1982. The brown pelican colony in Barataria Bay was flourishing.

From 1977 through 1978 an effort was made to establish a second colony of brown pelicans on either North Island or Isle au Pitre in the Chandeleur Sound, east of the Mississippi River. These two locations had been important traditional nesting sites for the Louisiana brown pelican. For four years, approximately 130 fledglings were released annually at North Island or Isle au Pitre. Logistically, this was a much more complicated release than the Grand Terre effort. The Grand Terre Marine Biological Laboratory provided an excellent base for personnel involved in feeding and caring for the young birds. There is no such facility at North Island. The biologists handling the program had to live aboard a boat for two or three weeks. Arrangements had to be made for the daily delivery of fish stocks. Mosquitoes and black flies made life miserable for the biologists and, presumably, the pelicans. Nevertheless, this transplant succeeded. A flight over the Chandeleur chain today will illustrate just how successful this program has been. On almost every island, from a few dozen to as many as a hundred or more pelicans will be found roosting, usually on a sandspit or beach, or fishing in the sheltered waters of the sound. This colony started nesting in 1979 and has fledged 229 birds to date.

It would seem that the reintroduction program has been an unqualified success. More brown pelicans are being fledged year by year, and the two colonies are growing. No transplants have been made since 1980. In Texas, where the brown pelican also disappeared (though the demise seems to have been a completely natural occurrence), the brown pelican is returning on his own. For the past five or six years two or three colonies have become established in the Rockport area on two small reefs and Pelican Island near Corpus Christi. Meanwhile east of the Mississippi River along the Mississippi Gulf Coast, the Alabama Coast, and the Florida Panhandle, brown

pelicans are being seen year by year in increasing numbers. During the late 1960s, and early 1970s, a pelican in any one of these three coastal areas was a rare sight. Today hundreds are seen in Panama City, Destin, or Fort Walton Beach, and lesser numbers at Gulf Shores, Mobile, or Dauphin Island. For the past two summers flocks of a dozen or more were seen regularly in Biloxi or Gulfport.

4

Pelicans of the Sunshine State

At the beginning of the twentieth century, pelican hunting was a big and bloody business in the state of Florida. It was not the meat of the bird that attracted hunters by the thousands (though edible, pelican meat is hardly for the gourmet), but its feathers.

With few or no state or national laws to protect them, brown pelicans, herons, egrets, and other birds with fashionable plumage were slaughtered by the thousands, particularly in prime nesting areas along Florida's Atlantic coast. Until a tragic incident occurred, it appeared that the mass extermination might go on forever.

The turning point was an ironic one. It was the brutal murder of a human, a warden of the National Audubon Society who had been gathering evidence of pelican hunting in Indian River County. Slaughter of pelicans might have been winked at in those days, when the species' population was counted in the scores of thousands, but the wanton killing of a human ignited outrage. Overnight, alarmed Floridians began demanding that Washington do something about a hunting situation that had so inflamed passions that a human life had been lost.

In 1903 President Theodore Roosevelt, a deeply concerned environmentalist himself, acted. Thanks to the urging of the Florida Audubon Society and the American Ornithologists' Union, he issued an executive order setting aside Pelican Island, in Indian River County, as the first in a network of national wildlife refuges. From that single three-acre refuge has grown a national system of more than 300 such sanctuaries around the country, protecting hundreds of species of birds and other animals. In yet another way, then, the brown pelican has served as the focal point in a broader program

involving all wildlife, and it is fitting and a tribute to Floridians' respect for the bird, that the national refuge system should have begun on a three-acre spit of land called Pelican Island.

Brown pelicans are known to have nested at Pelican Island at least since 1858. Its rich bottomland and mangrove thickets have in fact, proved to be one of the areas in Florida where annual breeding colonies have been fairly constant, not abandoned and then re-established in the willy-nilly fashion of pelican whim in some other areas of the state. Today, the boundaries of the original three-acre refuge have expanded to encompass more than 4,300 acres, and the bird that started it all is still around in substantial numbers.

The entire state of Florida, in fact, is one of the few areas of the brown pelican's national range where the species' population has not crashed in recent years. Although the pelican populations in California, the gulf states, Georgia, North Carolina, and South Carolina have dwindled markedly, and although the Florida population is reduced from what it once was, it still stands at a healthy estimated six to eight thousand breeding pairs.

Florida ornithologists, however, were not unaware that the decline occurring elsewhere could also happen in their state. In 1965 a worried Florida Game and Fresh Water Fish Commission decided to act before it was too late. That year, in what was to become one of the most important studies of the brown pelican yet undertaken, it authorized an annual pelican census to investigate possible causes of pelican troubles and to attempt to answer a wide-ranging list of questions about pelicans that might prove valuable in the future.

Lovett Williams, a noted researcher on the brown pelican, was retained to organize the census, and the project quickly gained the support of the National and Florida Audubon societies, the National Park Service, the Bureau of Sports Fisheries and Wildlife, and other wildlife-oriented organizations.

The task facing Williams was an imposing one; Florida's coastline extends 770 miles, and the shoreline, including bays and inlets, stretches to an even more impressive 5,095 miles, along the Atlantic and Gulf coasts. The commission had decided that the entire shoreline must be covered lest the census be fragmented and possibly useless.

With the brown pelican's population declining elsewhere, the Florida study suggested a rare opportunity for biologists. "Should the downward population trend continue in other parts of the brown pelican's range and spread to Florida," Williams told delegates at a conference of the Southeastern Association of Game and Fish Commissions in the fall of 1970, "we may have an unusual opportunity to monitor closely the extinction of a species during a relatively short period of time. This might produce knowledge and experience of use in saving certain other species from a similar fate. Or, if the populations in Florida maintain themselves, the study of these populations could facilitate an understanding of the population dynamics of the species which will not be possible in populations of questionable stability. More optimistically, the populations in Florida may offer hope that the species can be saved from extinction."

How best to conduct the census? In the spring of 1966, Williams and coworker Larry Martin made a preliminary aerial survey in a single-engined aircraft that took them almost the length of the state, from the Suwannee River to Key West. Although they did not attempt to make a complete inventory, they counted 6,920 brown pelican nests and confirmed that the airplane was the best way to do the job.

"But we also learned that it would be impractical to census pelicans from the air when they were not concentrated in nesting colonies," Williams remembers, "so that put a time frame on our work each year."

Three flights followed in the spring and summer of 1967 in which Williams and assistants found 21 active colonies of birds. Although only one of these was in the Florida Keys, in Monroe County, Williams noticed traces of nests left over from an earlier colonization in the Keys earlier in the year.

As the census became better publicized, bird watchers throughout Florida flooded Williams' office with telephoned information. Gradually, by piecing together various bits of data with those he had gathered, he began to get a better picture of the brown pelican's range in the state.

"The information," he reported in 1968, "suggested considerable seasonal differences from year to year in peak nesting activity in southern Florida. To determine whether more than one flight would be necessary in order to find some stage of nesting underway throughout the state, a one-day flight was made in late February of 1968 to ascertain the progress of nesting in the keys. Adult pelicans were found congregating at colony sites, but little nesting was underway. The only hatchlings were seen on the Marquesas Keys, west of Key West. They were very young."

Williams' work in nesting colonies in 1967 had indicated that pelicans cannot fly before they are at least nine weeks old. "With this in mind," he recalls, "it seemed safe to schedule a single flight of the entire coast in early May, 1968." Before taking this important step, Williams and coworkers scoured the literature and polled laymen and naturalists of the Florida Audubon Society and anybody else they thought might have vital historical information on nesting sites in the state. Altogether, fifty possible colony sites emerged; these were tabulated and then checked on the flight.

Nesting pelicans are quite apprehensive when humans or animals approach them from the ground; on hot or cold days hatchlings may die during the short period of time (five to ten minutes) that the parents are frightened away from the nest. But those observed by Williams were not unduly excited by the airplane, and by the time of the May, 1968, flight, Williams had established a census routine that worked quite well.

"A pilot handled the plane, leaving us free to observe without distraction. Both of us kept separate lists of the numbers of pelicans counted at each colony in an attempt to obtain an estimate of the variation in observer judgment. Although our individual estimates of the number of nests in particular colonies usually varied, our close agreement in the total count of all colonies provides a degree of confidence in the overall accuracy of the survey."

For a long time, ornithologists believed that pelicans shift the location of their nesting colonies, but it was not until the Florida study that the magnitude and significance of this had been explored. Williams found that some pelicans abandoned colonies that were previously very active, and others suddenly reoccupied old sites with several hundred nests. For this reason, he suggested, annual fluctuations in individual colonies probably disclose little, if anything, about the productivity of the species.

Yet, contrarily, pelicans cling to some nesting sites long after those sites appear capable of providing adequate supports for their nests. Pelican Island off Florida's Atlantic coast, for instance, is known to have been occupied by nesters at least as early as 1858. In spite of the fact that during some seasons storms and other causes killed all trees, forcing the birds to nest on the ground, the pelicans did not abandon Pelican Island until 1923. They were presumed, in a 1945 study, to be the same birds that established a new colony at Merritt Island, fifty miles north. Since 1945 the birds have returned to Pelican Island, but they also continue to nest on Merritt Island.

Colonies of pelicans on Florida's Gulf Coast, however, seem to shift locations more frequently than their Atlantic coast cousins. In his surveys, Williams found, in 1967, that many Gulf Coast colonies had been abandoned from the year before, and the same thing was observed when he returned a year later, in 1968. Why the difference only the width of a state away? From the evidence, Williams believes that pelicans tend to move about more frequently where better nesting sites are available, seeking to improve the safety and comfort of their nests, perhaps, because on the Atlantic coast where the offering is skimpier, they make do and move little.

"One of the interesting questions this raises is whether the pelican population could be increased on the Atlantic coast by the artificial creation of suitable nesting islands," he notes. At least, the additional

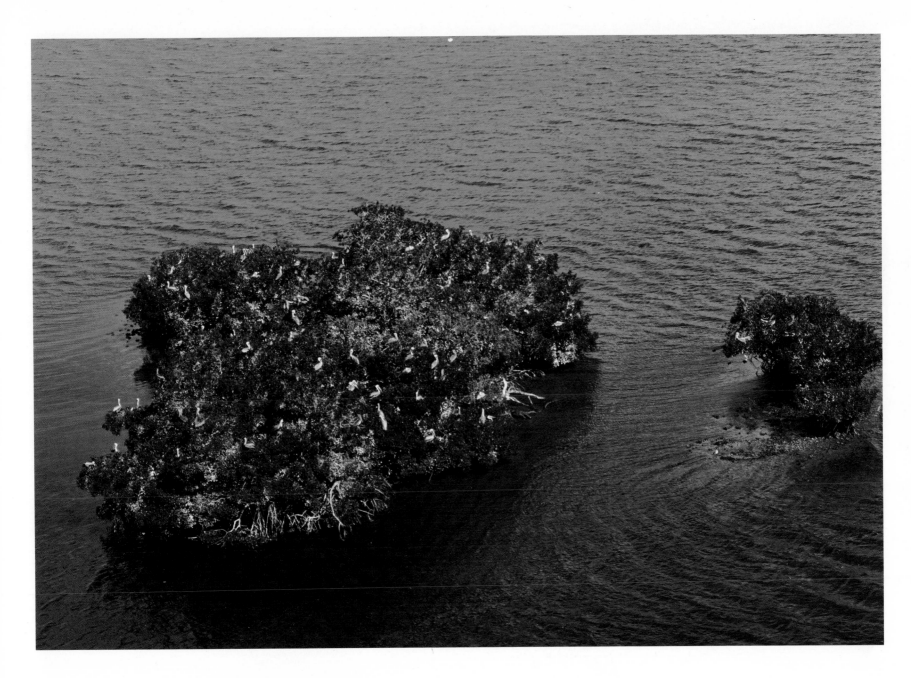

A small rookery in the Florida Keys, its mangroves virtually filled with young brown pelicans.

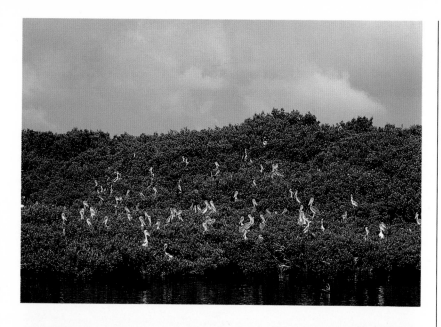

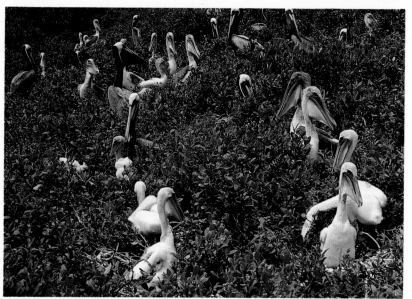

Left: Tarpon Key in Tampa Bay is the most populous pelican rookery in Florida. By June the mangroves are covered with pelicans, mostly fledglings.

Right: These brown pelicans were photographed on an island in Cape Fear River, North Carolina, where they started nesting in the late 1970s, along with several thousand terns.

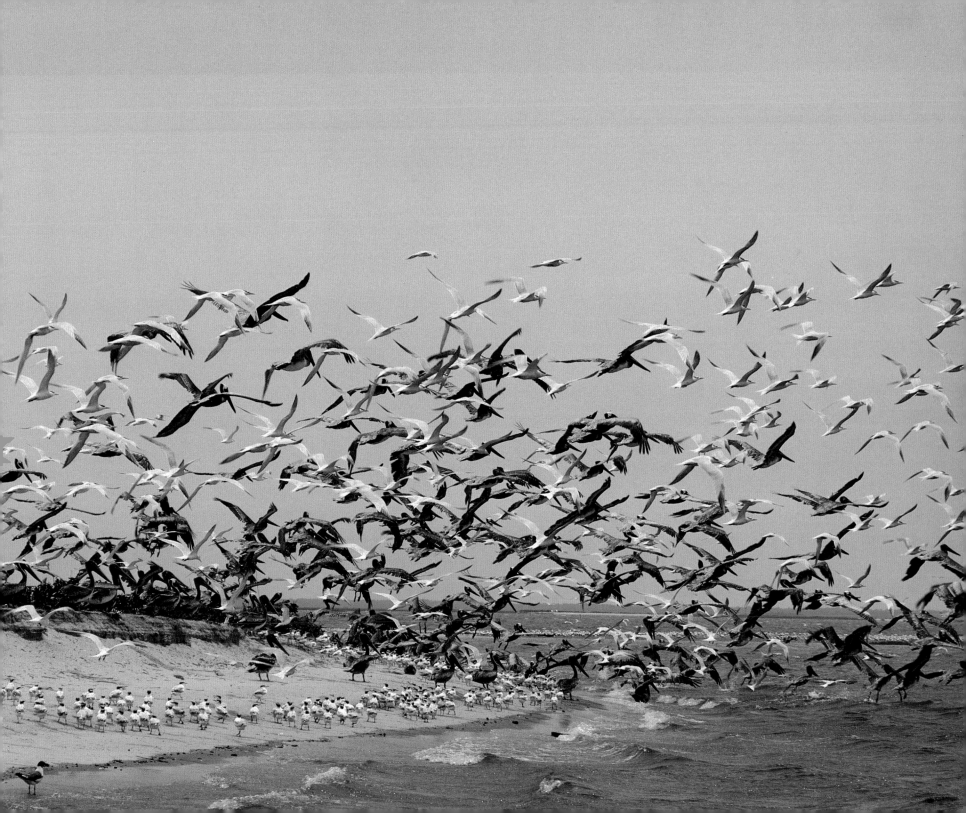

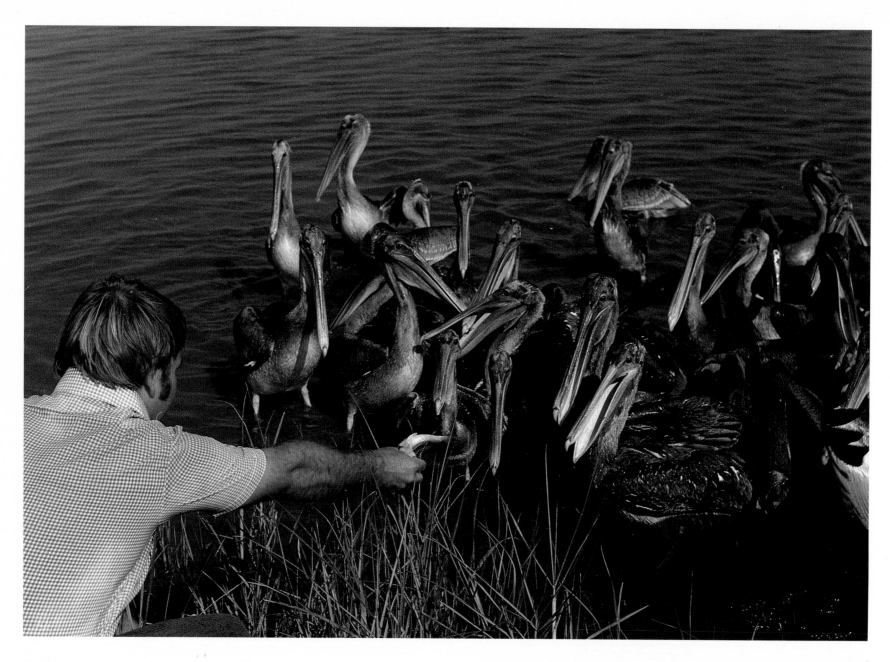

Above: Tommy Prickett, biologist, feeds fledgling pelicans brought to Grand Terre Island, Louisiana, from Florida. The birds were fed daily for several weeks until they were able to feed themselves.

66

Right: An aerial view of Camp Island, where nesting of the brown pelicans proved unsatisfactory. High tides washed over the low-lying island until the birds left for Queen Bess Island.

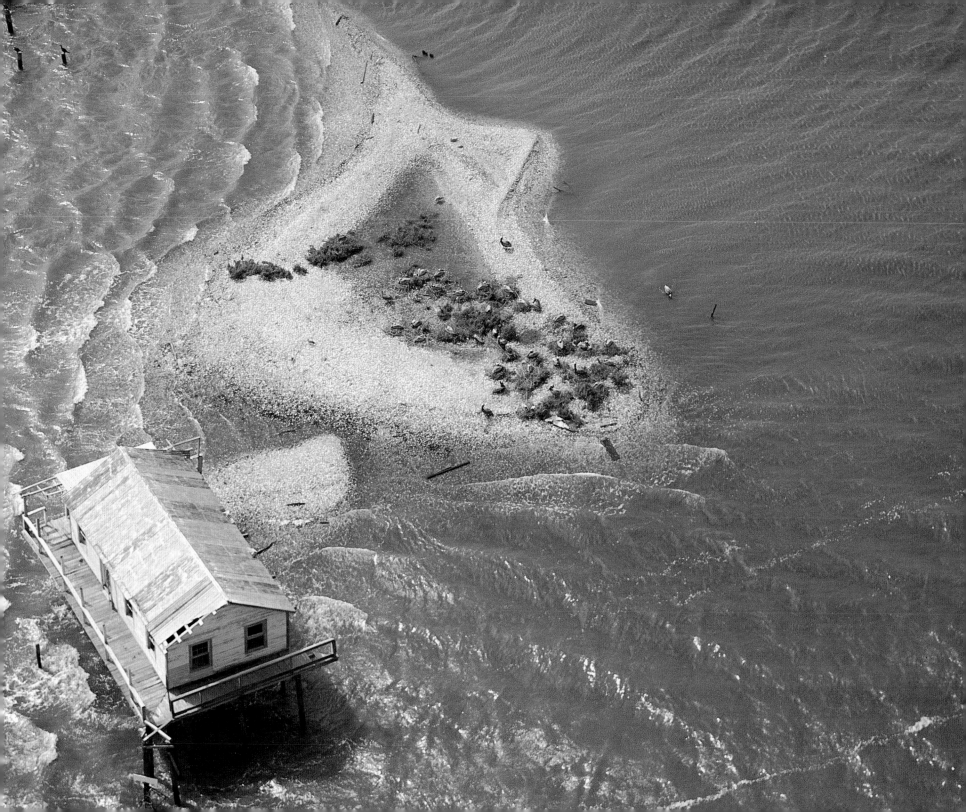

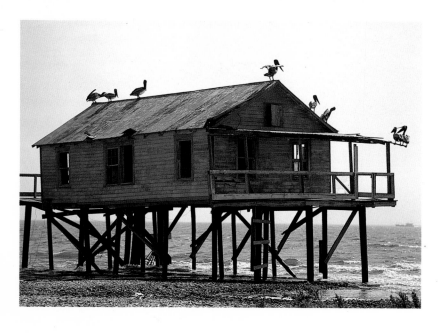

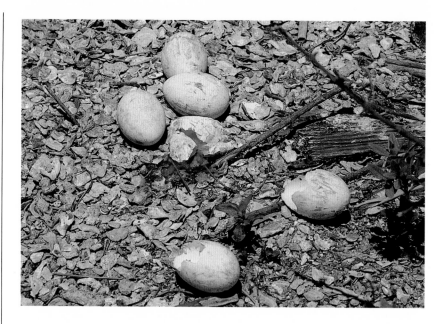

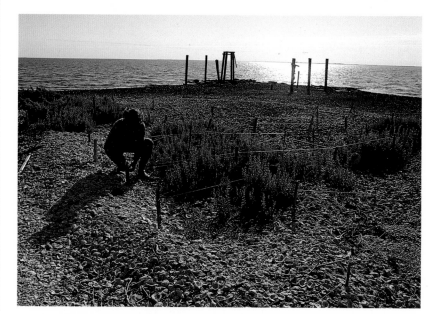

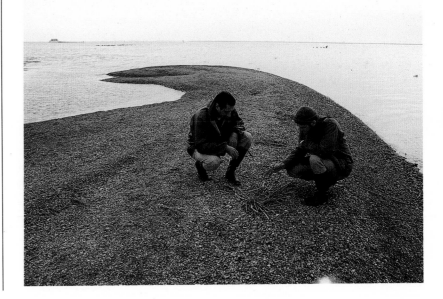

Left: Before moving to Queen Bess, the brown pelican made dogged efforts to remain on Camp Island in Louisiana. *Upper left:* Pelicans perch on a beach shack. *Lower left:* Biologists Ted Joanen and Tommy Prickett make notes on nesting birds and collect eggs for analysis. *Upper right:* eggs on the beach after high water washed out the nesting effort. *Lower right:* Steve Hein, biologist, erects a web of line to discourage pelicans from nesting on Camp Island (he later used aluminum pie plates to scare them away).

Right above: Brown pelicans congregate on a spit at Queen Bess Island, where they attempted to nest after they left Camp Island. *Below:* Biologists inspect remains of a nest on Queen Bess after high tide washed the eggs out.

69

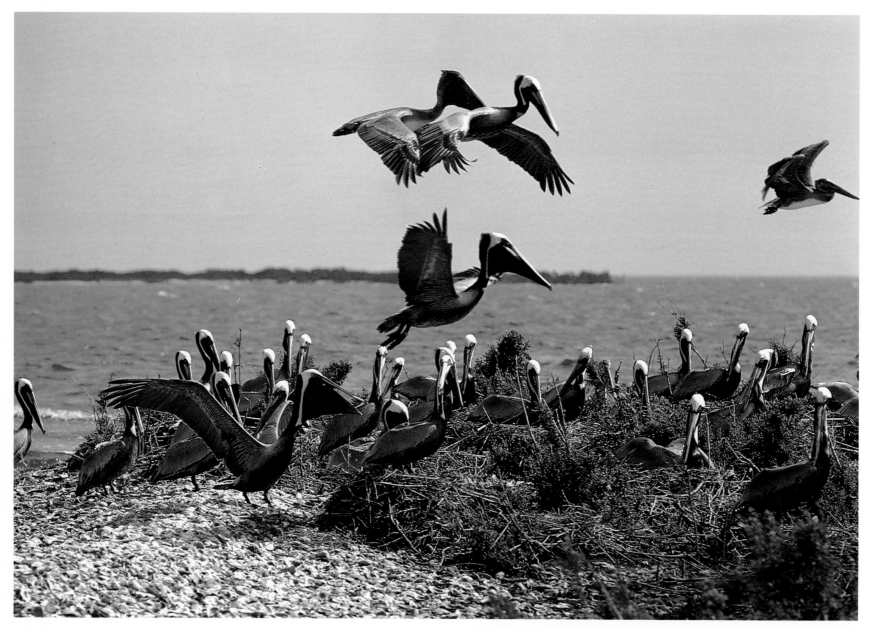

Right: After high tides wiped out their nesting efforts on the shell spit, the pelicans moved to some black mangroves on the other end of the island. This higher ground has the added advantage of being covered with mangroves, where many of the birds have nested over the years; the remainder of the colony has nested on the ground. In **70** 1971 the mangroves were little more than low shrubs. Today these same trees are several feet high and provide the pelicans with nesting sites high enough to keep the nest dry in the highest spring tides. *Above*: A closeup of the successful pelican colony on Queen Bess.

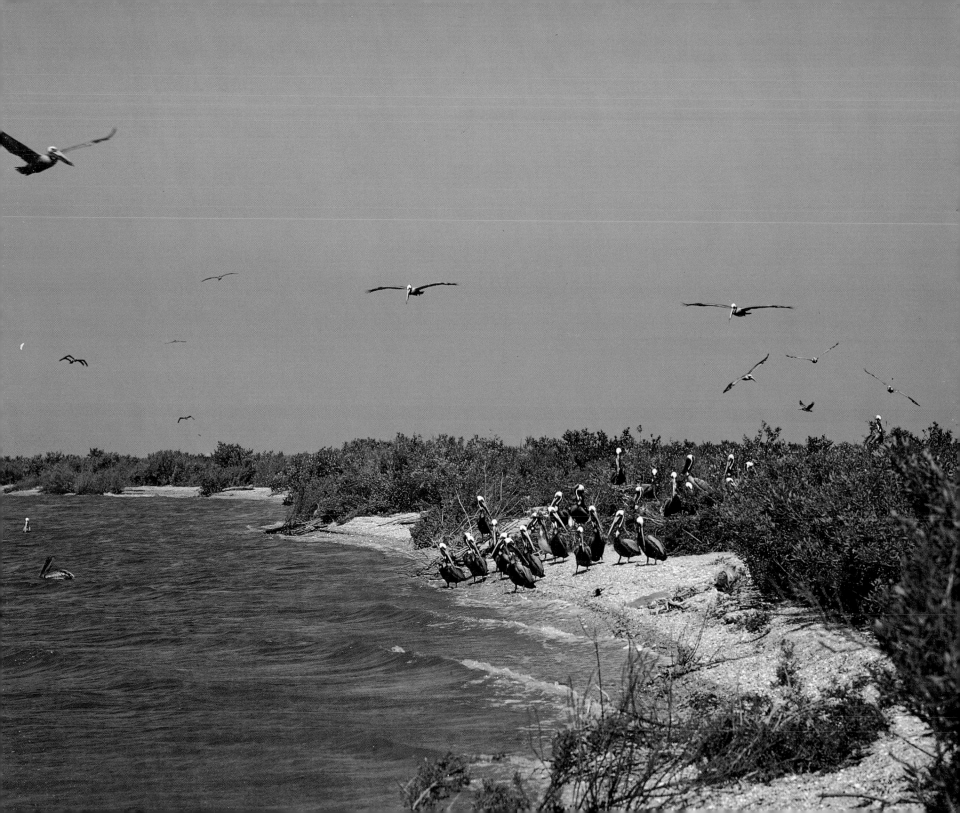

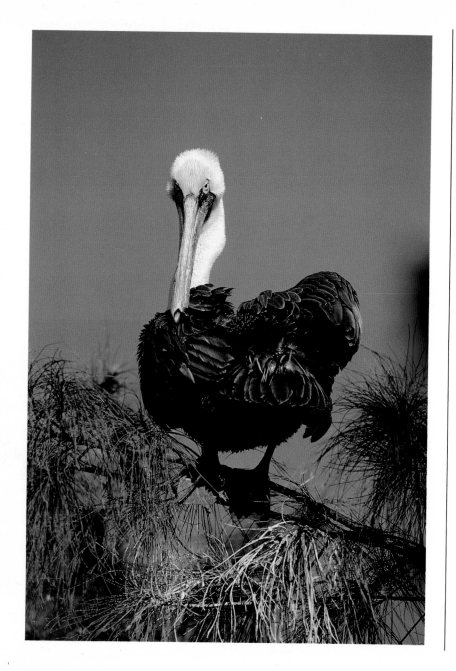

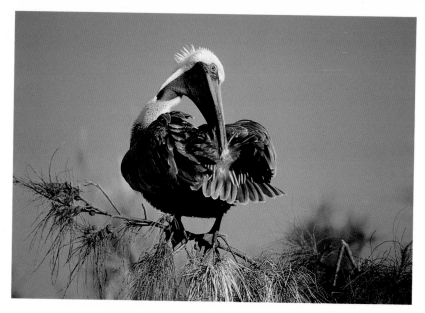

Above: This pelican is taking oil from his preening glands. Preening is not merely a cosmetic function but one necessary to healthy plumage. *Left:* Here the pelican is applying oil to his feathers. He runs all the feathers through the mandibles, somewhat like a zipper, several times each day.

Right: A preening brown pelican rubbing the back of his head on his preening gland.

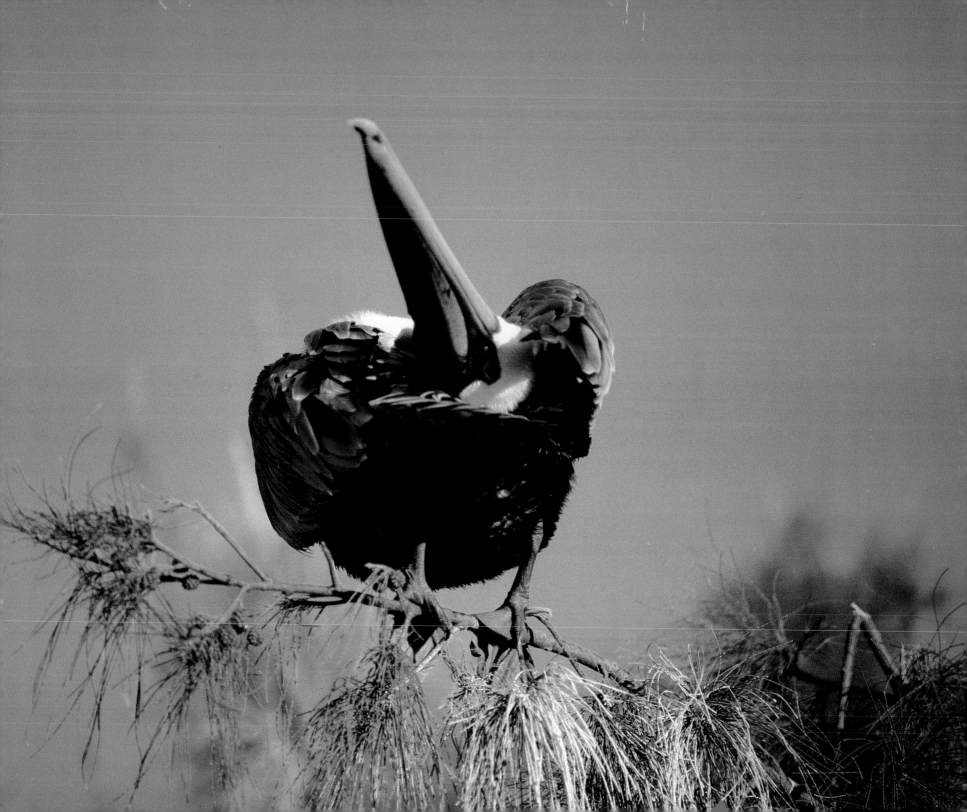

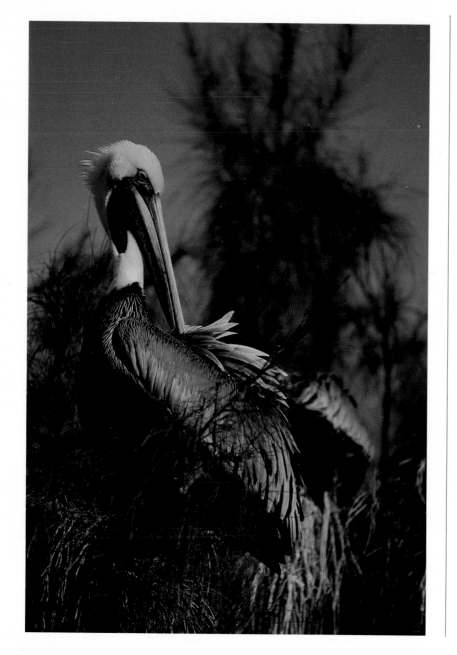

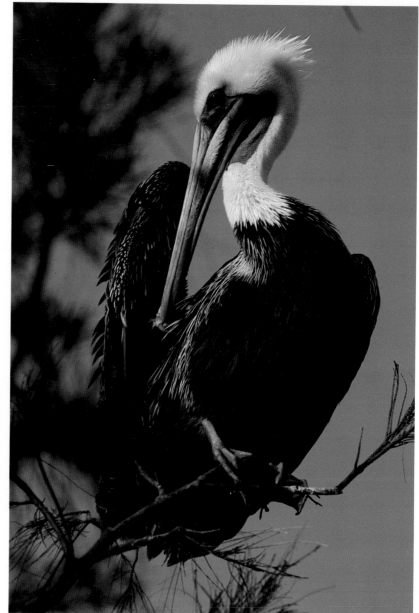

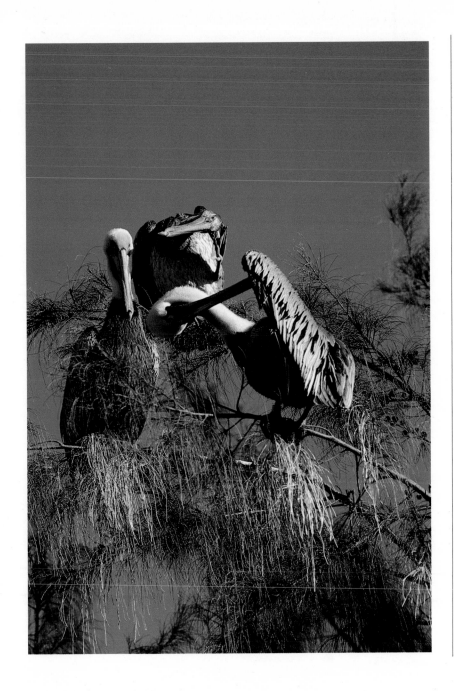

These preening mature pelicans perch above pen number five in a rookery at the Suncoast Seabird Sanctuary.

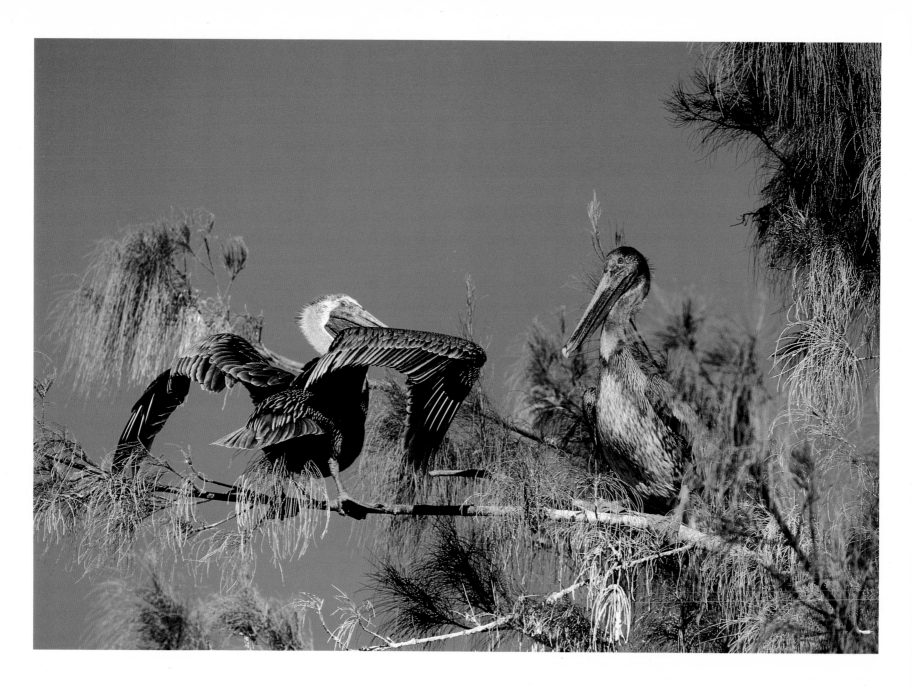

An example of pecking order among brown pelicans. A sexually mature bird attempts to chase a young pelican off a limb.

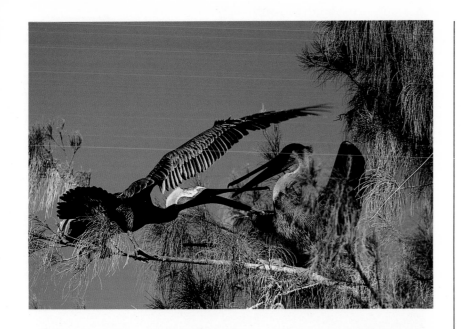

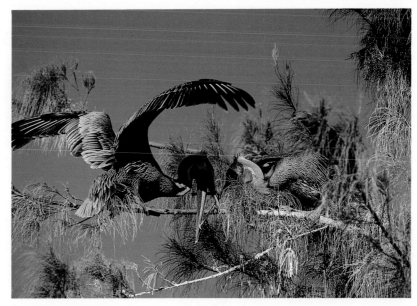

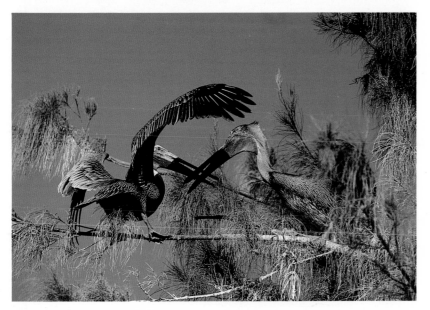

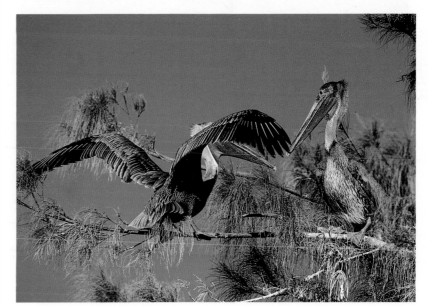

These four pictures and the picture on page 78 present the fight progressing between the sexually mature pelican and the two-year-old. The older bird establishes his dominance by chasing away the younger pelican.

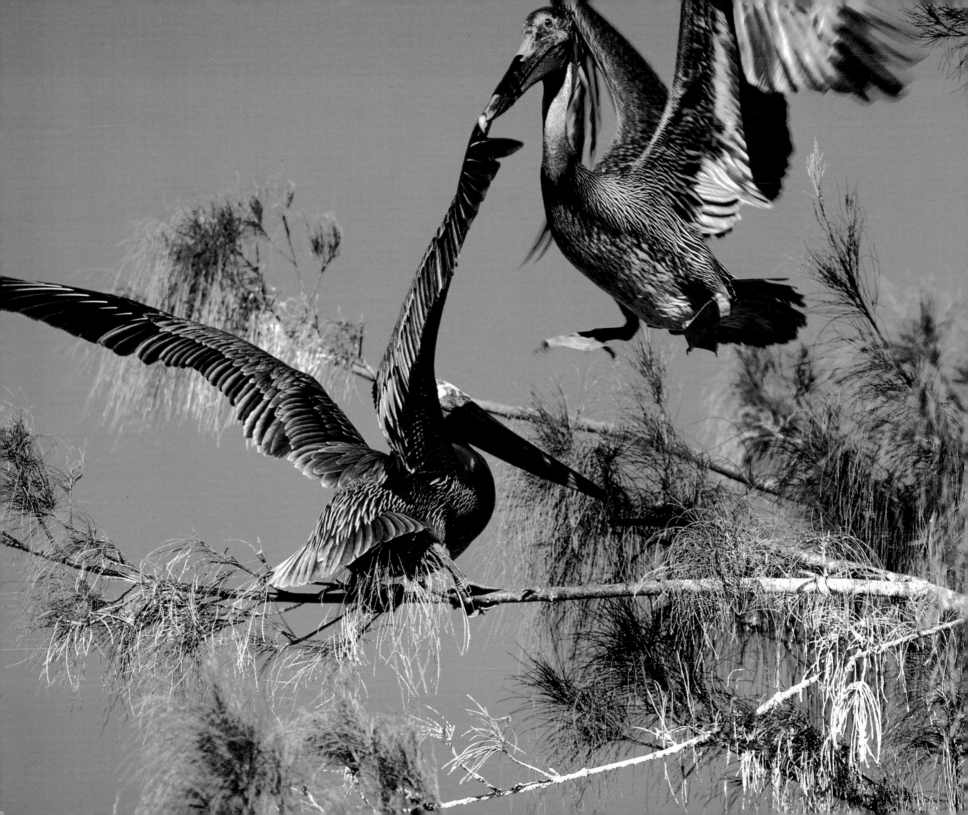

island sites would reduce the crowding of the colonies that Williams' study confirmed. For instance, of 18 active colonies found in 1968 in the gulf area, where suitable sites were more numerous, each contained an average of 261 nests; there was an average of 333 nests—23 percent more—in the scant six colonies on the Atlantic side of the state.

It is an established theory among naturalists that crowding can adversely affect lower animals just as it does humans who live in teeming metropolitan areas. Disease spreads faster and can affect more animals more rapidly. Extreme weather conditions that destroy nests and chicks obviously would not affect as many birds if colonies were more widely dispersed. And the low number of good nesting sites may have much to do with mass pelican migrations. It even may provide a clue to why Louisiana's brown pelican was extirpated in so short a time.

"At this time," Williams reported in 1968, "it is not known whether the brown pelicans which once nested in Louisiana may be alive and healthy somewhere else; nor is it known whether decreases observed in South Carolina are because some are simply moving to Florida."

Other scientists are fascinated by this possibility, but because earlier no one meticulously studied the various factors affecting interchange of pelican colonies, they can only guess at answers. Had past generations become as concerned with the plight of the pelican and other species of wildlife as the present one has, the accurate information so vital to understanding an exodus might have been uncovered long ago. But that is hindsight. Man now *has* made a substantial start in the area of research that may help him in the future to better understand mysterious and abrupt shifts in the behavior of the brown pelican.

Williams' plea that aerial surveys, such as those used in Florida, be made on an annual basis seems absolutely sound. But if an improved survey method is determined to be better than aircraft, it should be employed. Repeatedly, ornithologists have stated that the brown pelican makes an ideal "monitor" animal; that is, he is, in effect, a very fragile "early warning system" of adverse factors in his environment

that will eventually affect a much wider span of wildlife species. In this regard, he fulfills a function like that of the canary once carried by the coal miner to warn of gases even before the miner could detect them himself. Ultimately, the factors affecting the pelican can affect man. Closely monitoring the brown pelican, therefore, is not merely a costly exercise that will benefit one species of bird, but is vitally important to a large segment of the animal kingdom.

Mysterious mortality and illness are often reported in wild pelicans. Parasites are common in the gastro-intestinal tract, but these worms are not likely the primary cause of a pelican's demise. They may weaken a bird so that death could result from a number of causes, but because the species has received limited study, little is known about natural mortality in the brown pelican. In Louisiana and California, at long last a start has been made in this direction.

The Florida study verified some long-standing beliefs about the bird and its habits, but it also turned up some surprising new information. All pelican colonies observed were found to be on islands. That was not surprising since in Louisiana and California the birds have also been island nesters for as long as man has observed them. (One very small Florida colony nested on a man-made spoil island, but all others were on natural islands or on natural islands that had been used for spoil dumping; the birds did frequently visit numerous narrow peninsulas, but apparently only for nesting materials.)

More unexpected was the fact that many of the larger colonies were established close to centers of human activity. A large colony at Port Orange was right on the edge of the heavily traveled Intracoastal Waterway, and only about 150 yards from a highway drawbridge. At Fort Pierce, pelicans built nests not far from an occupied house. And at Cocoa Beach, other pelicans moved inside the city limits to nest only 100 yards from a dredged landfill that supports a private housing development.

"The effects of human disturbance in nesting colonies and the upper limits of the species' toleration of human activities close by is something we don't yet understand," said Lovett Williams, "but it is

evident that nesting may proceed with at least some success in human population centers. To learn more about human disturbance, we'll have to do more studies."

The factors controlling the nesting distribution of Florida pelicans also need careful study, he adds. The most northern colony in Florida on the east coast is near the same latitude (29°09′N) as the northernmost colony on the west coast of the state (29°06′N). These correspond closely to the northern limits of the brown pelican in Louisiana (at North Island, 29°50′N). One thing that these three locations have in common is that they are on the northern edge of the range of black mangrove.

Florida pelicans nest in trees almost exclusively, and if trees aren't available, they pick the next best thing. In one colony established on a treeless island, a pair of birds chose an overgrown pokeweed; it was the only vegetation on the island that could support a nest.

Unlike others of the species in Louisiana and California, Florida's pelicans not only prefer trees but try to nest as high in them as possible. Earlier nesters pick the best sites, and those that follow have to make do with what is left over. When the tallest trees are not suitable for nesting, the birds nest around the rim of the island or cluster on points. Tree heights in Williams' study ranged from 40-foot live oaks at Seahorse Key to black mangrove averaging about seven feet (but with some much lower nests) on the eastern coast. Gulf pelicans seemed to prefer red mangrove, whereas those on the eastern coast nested almost exclusively in black mangrove.

Choosing the right tree is not as easy as it may sound. First, the tree must have branches strong enough to support the bird and nest, with foliage not thick enough to impede the large bird's entry. Second, it has to be situated in such a way that the bird has complete freedom in flying away. Anyone who has observed a pelican landing or taking off realizes that several hefty beats of the outstretched wings require plenty of room.

Williams and others have urged that a continuing conservation program be developed with the specific purpose of saving the brown pelican as a species. To do so means that "pelican science" should not be hampered in any way. "In the event of continued population declines and local extirpations, restrictive state and federal regulations that impede research and scientific management of brown pelicans will only hasten—certainly not halt or even slow down—the eventual disappearance of the species."

All brown pelicans are on the endangered species list of the Department of Interior. Although this may seem to have given the pelican a blanket of security and thus helped perpetuate its population, just the opposite may be true. By law, animals and birds on Interior's list may not be hunted or captured, except for research and scientific purposes or display in legitimate zoos. Passage of the Endangered Species Act a few years ago was widely hailed, but many of its most enthusiastic supporters now have some serious misgivings.

Although they support the measure in principle, operators of legitimate zoos, wildlife centers, and research institutions almost universally agree that in enforcement it has become so bogged down and ensnared in bureaucratic red tape that it is in danger of foundering. One section of the law, for instance, prohibits the transfer of any endangered animal from one place to another without a permit from the administering federal authority. The intent of this provision seems justified; for one thing, it helps stop inhumane trafficking in exotic pets and the proliferation of "roadside zoos." Legislation to halt such abuses was long overdue. Yet, because of either woefully undermanned staffs in the appropriate departments or just plain ineptness, processing of these applications can take months, even up to a year, and especially in cases where transfer is intended for breeding purposes and a short time frame is biologically urgent, the whole purpose is thus lost. Many scientists doing research on endangered animals have become so exasperated trying to cope with this mess that they have turned to other, easier pursuits. The same thing could happen to well-meaning biologists who are studying the brown pelican, prominently displayed on Interior's endangered list, unless the tangle in Washington is straightened out.

Research and continuing study are the key to the brown pelican's survival in Florida and elsewhere. We need to know substantially more about how the bird lives in order to prevent it from dying. Not only knowledge of the pelican itself is needed but also knowledge of the entire habitat and the complexities of the interlocking food chain within it.

In late 1972, for instance, observers in the Naples, Florida, area learned to their distress that hundreds of pelican fledglings were dying of some unknown cause. Certainly, there was an abundance of fish. Subsequent study by Ralph Schreiber, then a young graduate student at the University of South Florida, suggested one possibility.

Somehow, the birds had lost a considerable amount of the extra body weight and stored energy required during the critical fledgling period. When young brown pelicans leave their nest, they weigh two to three pounds *more* than their parents (true of many if not most raptorial species). This is nature's way of giving the fledglings a small storehouse of energy to tide them over while they learn to fish for themselves. If for any reason the supply of food is scarce and the young birds use up their reserves before they learn to feed themselves, they can starve. They soon lose all muscular coordination, and the nerve pathways are damaged. Then, they simply waste away and die. Once brown pelicans fledge, it must be remembered, they are entirely on their own; never again in their lives will another bird—even their own parent—help them.

Observing the die-off in Tampa, Ralph Schreiber estimated that in this one colony alone, 10,000 pelicans had fledged. But because something had interrupted the cycle of life—in this case, something that apparently had reduced the available food supply—he estimated that only 2,000 or so would live to adulthood. The cause of the starvation was never precisely determined, but a number of factors, including pollution that decimated available fish, were suspected.

Twice in succeeding years, mysterious brown pelican die-offs were reported in Florida. The first occurred in early spring, 1973, when first a handful, then as many as 40 or 50, brown pelicans were found dead on gulf beaches near St. Petersburg. The birds did not appear emaciated, so starvation was ruled out. At St. Petersburg, Ralph Heath gathered several carcasses and took them to Dr. Harry Albers' office for further study. These carcasses and many others collected that same year subsequently were forwarded to the U.S. Fish and Wildlife Service pathology lab in Madison, Wisconsin. The tests indicated high concentrations of *Escherichia coli* in the bloodstream. Apparently a particularly virulent strain of this organism was spreading through the Tampa Bay brown pelican population. The organism was possibly being picked up by birds fishing in polluted waters. By April, almost five sick birds a day were being brought to Heath's Suncoast Seabird Sanctuary; in almost every instance, *E. coli* was the culprit.

A related phenomenon was then noticed. Not only along beaches, but on golf courses, airport runways, highways—from Fort DeSoto to Oldsmar—the sick birds wobbled about, as if drunk or seasick, barely able to lift off the ground, finally ramming into solid objects. Every bird brought to Suncoast died; those that survived the effects of the sewage bacteria succumbed to injuries caused by its effect on their flight.

Ironically, the healthiest, strongest birds were stricken first, apparently being the ones best able to fish in the sewage-contaminated waters. "When the birds became sick, they didn't care where they landed, whether it was a soft lawn or the side of a house," Heath recalls. "An Indian Rocks Beach family thought a plane had crashed when a pelican rammed into their glass jalousie door, knocking out 15 panes."

On its last flight, the sick pelican would fly about three or four feet above the ground and in a straight line until it smashed into a solid object that killed it. In lesser numbers, the same thing was happening to herons, egrets, and cormorants.

For many seabirds, mainly ducks, cormorants, plovers, and mergansers, disaster struck again at St. Petersburg the following December. This time, though, man could not be blamed. The cause was a

mysterious phenomenon known as the "red tide," an occasional recurring "natural pollution" of coastal waters in Florida, California, and elsewhere, that causes a red discoloration in miles of water and a subsequent lethal effect on fish and many other forms of marine animals. Scientists believe that red tide is caused by an extraordinary multiplication of some minute living organism, often a dinoflagellate.

At St. Petersburg, Heath's bird hospital was soon jammed with winged patients, all believed to be victims of the sudden red tide. First came the mergansers, followed by cormorants and other birds. All displayed the same symptoms; although they seemed alert and accepted food from Heath's volunteers, they were badly emaciated and apparently could not recover from the effects of the sea's adverse chemistry. Gradually, their systems seemed to wither, the birds went to sleep, and within hours were dead.

Although the red tide still is strongly suspected as a cause of mortality, the evidence in the early eighties is inconclusive. In fact, mortality of the birds in question may have occurred from an entirely new disease. Once again, too little is known even today about the many factors that occasionally ravage populations of this officially endangered species.

In Florida, especially, loss of habitat and increasing disturbance by man are two other factors adversely affecting the brown pelican. Nor are DDT and its related chemicals immune from a share of the blame. Schreiber postulates that the Florida brown pelican may suffer the same kind of extirpation that struck once-thriving colonies in Louisiana and California, but that it may come more slowly because the adverse effects are not as great. Subtle changes in productivity will not affect the total population of pelicans for many years, he suggests, because of the pelican's relatively long life span. Before man realizes what is happening, in other words, it may be too late.

Ralph Schreiber's work has been of considerable value to Florida's efforts to learn more about the brown pelican. For several years, he has made extensive observations of the bird during its breeding sea-son on Tarpon Key, part of a 377-acre national wildlife refuge in Tampa Bay. Although the pelicans seem far better adapted to life on the key than the human observer (once a 12-foot jerry-rigged observation tower collapsed under Schreiber with loss to two cameras and considerable dignity, and more than once he has found himself neck deep in mud while attempting close-up studies), his notes have filled significant gaps in our knowledge of Florida brown pelican migration and colony behavior.

Tarpon Key is a popular pelican breeding site. The number of nests observed there by Lovett Williams' annual aerial survey has fluctuated between 800 and 1,300—the most populous single site in Florida. Ironically, it is also very close to a booming complex of human habitation; more than one million people live in the greater Tampa– St. Petersburg area.

In the fall and midwinter months, only a few idle brown pelicans frequent Tarpon Key, where they have become familiar moochers of fishermen's catches, a comic relief to the busy Tampa–St. Petersburg waterfront. But in late February, as the breeding season approaches, the wintering few begin to congregate in the mangrove thickets of Tarpon Key itself and other islands, where, joined by other pelicans who have wintered elsewhere, they get down to the serious business of raising families.

Since 1969 biologists of the Cape Romain National Wildlife Refuge in South Carolina and the Florida Game and Fresh Water Fish Commission have banded and color-marked nestling pelicans at Tarpon Key and elsewhere to better establish how these migrations occur. For leg bands, they used U.S. Fish and Wildlife Service numbered aluminum markers; they also attach colored plastic streamers on leg and wing. Identifying the bird from a distance is made possible by the bright color of the band, and both types of bands are light enough that they do not harm the bird or impede its progress in flight. After banding the birds the participating agencies, through newspaper alerts and posters, seek the help of the public in tracing the migra-

tion of birds after the breeding season ends. Response to the program was tremendous; an average of 1,500 sightings was reported by lay citizens between 1969 and 1973 alone.

From the evidence, observers have determined that brown pelicans banded as nestlings in South Carolina move south during the fall and winter nonbreeding seasons, whiling away the winter months on the east coast of Florida and in the Florida Keys. Banded west coast Florida pelicans also move south during fall and winter. So far, the program has established only three incidents of brown pelicans migrating from one coast of Florida to the other. A scattered few from various sections of the eastern United States have been recovered as far south as Cuba, the Bahamas, and Guatemala. Since historical evidence indicates that the brown pelican, unlike the white pelican, does not move far, these scattered few are long-range drifters indeed.

The banding also helps scientists learn more about the lifespan of brown pelicans. One recovered banded bird was determined to be twenty-five years old. Far more common is less happy evidence, however; "Although recoveries of birds between 5 and 20 years are numerous," Schreiber reports, "most banded birds recovered dead are less than a year old." (Without bands, it is almost impossible to tell the age of a mature pelican.)

From his studies, Ralph Schreiber believes that failure of fledglings to learn how to fish is a major cause of brown pelican mortality, and this would seem to support reports of so many pelican bodies recovered not long after they have left the nest.

Despite natural and man-made hazards, the encroachment by man upon his habitat, the poisoning of his food supply, an unexpected red tide,—as only three examples—the Florida born pelican is holding his own as nowhere else in his North American range. The population in Florida actually is increasing, and is spreading northward. Yet, as Williams, Schreiber, and others plead, this is no reason for complacency. In view of what happened so quickly in California and Louisiana, the brown pelican of the Sunshine State must be considered as endangered, and the important efforts to isolate the many factors that threaten him must be continued.

"If the brown pelican is permitted to become extinct," Lovett Williams concludes, "it will not be because we were not amply warned."

5

The Pelican in California

Seventeen miles south of San Diego, California, the four rocky, barren Coronado Islands of Mexico rise precipitously out of the sea. Discovered in 1542 by Juan Rodriquez Cabrillo, the Portugese navigator who was sailing under the Spanish flag, they have been a mecca for adventurers ever since, and a haven for marine wildlife for much longer.

During the Gold Rush, pirates lurked in the Coronados to prey on gold-laden ships voyaging south toward Cape Horn. When America went dry during Prohibition, a $200,000 gambling casino and resort built there attracted thousands of thirsty Southern Californians. The location of the islands in Mexican waters close to the American border made them an ideal transfer point for smugglers.

As for wildlife, Cabrillo discovered that the Coronados had been claimed as a home by great numbers of harbor seals, sea lions, elephant seals, and sea otters, as well as dozens of species of seabirds, including the brown pelican. And, nourished by thick kelp beds, the underwater shelf of the Coronados supported substantial populations of fish, lobster, and other marine life.

Almost from the time of Cabrillo's discovery, man seemed savagely bent on destroying the natural community of these islands. Sealers reduced the sea lion population, and sea otters became extinct here early in the twentieth century. Japanese and Chinese divers almost obliterated the Coronados' abalone, a single-shelled clamlike animal highly prized for its pearllike shell. As for the birds, sportsmen had found an ideal shooting gallery; it has been only since 1924, when Mexico officially listed the islands as a bird sanctuary, that their cormorants, petrels, auklets, and pelicans have received any protec-

tion from human predators. And underwater, where 300-pound black sea bass were not uncommon, scuba-diving spearfishermen found a bonanza in these islands that Cabrillo called Las Islas Desiertas—the Desert Islands.

For a time, it appeared that the brown pelican might be another victim of man's destruction. But in the pelican's case, it was not hunting or poaching that threatened its existence; it was the highly controversial pesticide, DDT.

It was in the Coronados and other Mexican-owned islands to the south, as well as in the Channel Islands to the north, which are owned by California, that the DDT crisis simmered in the late 1960s, came to a boil in the early 1970s, and finally was resolved with restriction of the chemical's use in the United States in 1972.

Although some limited use of DDT under rigidly controlled conditions has been allowed in the country since then, its general banishment has paralleled, not coincidentally, a general increase in the population of the California brown pelican in the Coronados and in the Channel Islands west of Santa Barbara.

Like all other brown pelicans, the California bird prefers to nest on islands. Unlike the low-lying islands of Florida and Louisiana, however, those off the coast of the two Californias are generally islands that jut sharply and fairly high out of the sea. Although it is only one-half mile long, for instance, North Island of the Coronado group rises to almost 470 feet, and its craggy cliffs offer many splendid sites for pelican nests.

Whereas most of California's Channel Islands are lush in ground cover and small trees, the Coronados are practically devoid of vegetation. This makes little difference to the fish-eating brown pelican, and there are enough sticks and sparse shrub growth to furnish the necessary nesting material. Small pieces of driftwood found along the Coronados' shoreline often augment other nesting materials. (A popular mecca for yachtsmen and fishermen, the shoreline is also littered with plastic beer six-pack binders. Although it has not been observed in the Coronados, scientists have noted pelicans elsewhere building their nests with these nonbiodegradable tokens of society.)

Although the Coronados figure prominently in the California brown pelican story, it is on another island that the story really begins. That island is Anacapa, a rocky four-mile-long sentinel that pokes out of the sea only nine miles from the southern California coastline. The remnant of a mountain peak, it is constantly exposed to wind and weather. Gloomy channel fogs cling to its shores much of the year.

For years, Anacapa was the only important nesting ground of the brown pelican in California. The number of birds counted there in years prior to the 1960s varied from season to season, but it was substantial. Despite its somber nature, Anacapa was a preferred haven for West Coast pelicans.

In March, 1969, a group of biologists led by Dr. Robert Risebrough of the University of California's Institute of Marine Resources at Berkeley, began a visit to Anacapa and its sister Channel Islands, with the assistance of the National Park Service, which administers a portion of them. Dr. Risebrough knew from records that the brown pelican had nested on Anacapa as recently as 1964, five years prior to his visit, and all seemed in order when he found approximately 300 pairs of birds nesting on a crest of the westernmost portion of the island.

Upon closer examination, however, the scientists glanced at each other in astonishment. Although parent pelicans were sitting on their nests in great numbers, the nests themselves were either empty of eggs, or the few eggs that lay there were crushed. Dr. Risebrough checked 298 eggs and the story was the same: parents nesting, crushed eggs (some useless egg remnants had been kicked out of the nests), or no evidence of young at all. Of the twelve nests that contained eggs, nine held but one egg each; Dr. Risebrough noted that all had been lined with fresh plant material, an indication that the eggs were replacements for others lost earlier in the season.

Curious and worried about what he had seen, Dr. Risebrough returned to Anacapa in late March. All eggs were broken. By mid-April, even the parent pelicans had vanished, and the colony was deserted. What had happened? After extensive research, involving analysis of eggs and egg remains, the chemical DDT was blamed.

A chemical compound first discovered in an English laboratory in 1874 and rediscovered in Switzerland in the 1930s, DDT proved a major boon to agriculture and therefore to humans. First used commercially as a mothproofing agent, the chemical, according to one source, is directly responsible for saving "100 million human lives" in the fight against insect-borne disease. Though now banned in the United States, DDT is still a major weapon against malaria, dysentery, and typhus in emerging Asian and African nations.

Its use was accelerated during World War II. DDT was at first a "miracle chemical" to nations like Russia, which had lost several million soldiers to typhus during World War I. Because of its enormous power, DDT was used judiciously at first, and only after extensive testing and research. One of the first wide-scale applications occurred in April, 1943, in an Italian town where a typhus epidemic had broken out and which local doctors estimated would cause at least 250,000 deaths before it was arrested. Spraying the community with DDT reduced the death toll to a token number. It was also used to delouse German prisoners of war, and in the Pacific, aircraft carrying the pesticide sprayed invasion routes in advance of troops, thus greatly reducing the possibility of disease.

When World War II ended, DDT reverted to civilian use. By the mid-fifties, it was being hailed as a massive new weapon against destructive agricultural pests, and like many products that are at first regarded with suspicion, its eventual acceptance turned to abuse; the earlier controls and rigid restrictions simply vanished. So much for its benefits, all of them well documented.

Used as a pesticide on agricultural crops, DDT, like many insecticides liberally applied to the land, eventually finds its way to the sea in tremendous quantities. Unfortunately, unlike many other chemical compounds whose strength quickly dissipates when diluted in water or air, these pesticides remain in the environment at full strength for many years. Not only is the organism that the chemical agents contact directly affected, but other organisms involved in the same "chain of life" as the original one. In the sea, this chain of life (or "food chain" or "food web," as it is alternately called) is delicately woven.

When pesticides washed down from the land invade the sea, they are first accumulated by surface plankton. They are then passed along the food chain upward through invertebrates and fishes; finally, they reach fish-feeding birds such as the brown pelican and other top-level predators. At each level, they are not merely passed on, but are usually concentrated in the fatty tissues of many organisms. Scientists call this phenomenon *biological magnification*, and it explains why animals at the end of the food chain, including the pelican, may accumulate toxic DDT and other chemicals in massive dosages.

Biological magnification was explained by Dr. Robert L. Rudd in *Pesticides and the Living Landscape* in relationship to organisms at Clear Lake, California, where DDD, a close relative of DDT, was used to control gnats. An examination of the lake disclosed that plankton there had a pesticide level 265 times that of the lake itself. Small fishes that fed on the plankton contained 500 times the lake level. And in the fat of western grebes, which fed on the fishes, the DDD concentration had increased to 1,600 parts per million, or 80,000 times the concentration of pesticides applied to the lake. It was estimated that, because of this single case of biological magnification, the lake's original grebe population of 3,000 was reduced to only 50 or 60 birds.

The severest indictment of DDT was its possible harm to man, even as a cause of cancer. Laboratory tests in France have shown that the rate of tumors increases in mice exposed to DDT. Other scientists studying the findings determined that the tumors were

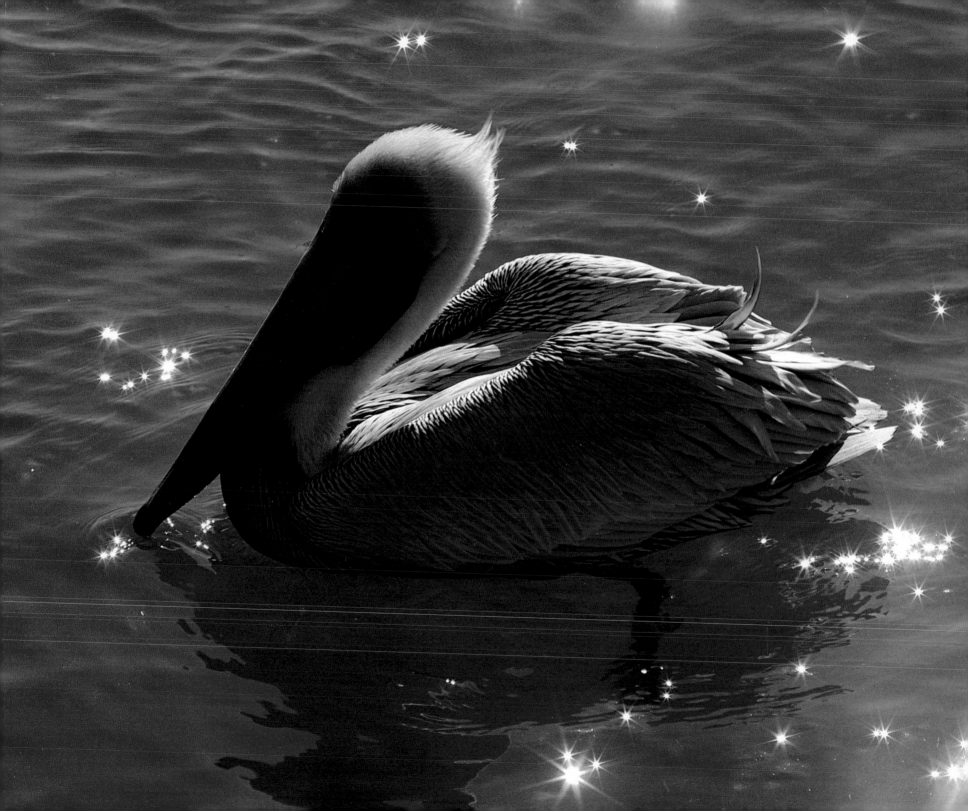

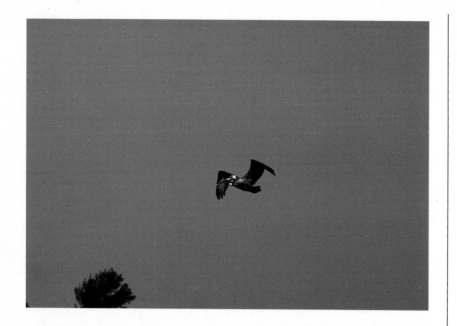

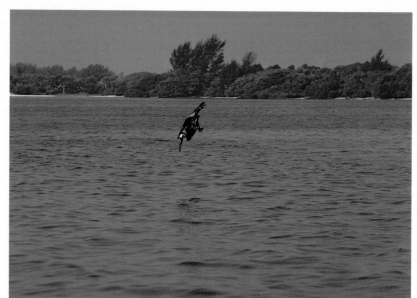

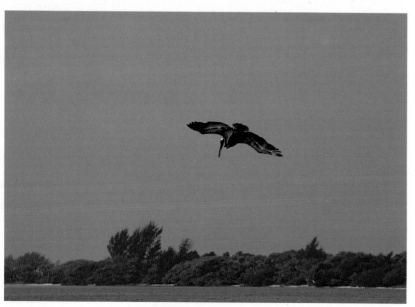

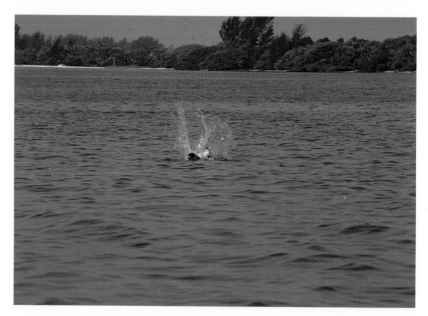

One type of feeding is by diving. The pelican usually dives into a school rather than for a single fish. From approximately twenty feet, this pelican descends with increasing speed, feet stretched straight back under the tail, wings flattened tightly back, and neck tucked back. His bill is pointed directly downward, the expandable pouch tightly closed. When the tip of the bill touches the water, it opens and the pouch expands, scooping up as many fish as can be quickly caught, sometimes hundreds of tiny minnows. The pelican then turns around underwater, facing the wind before surfacing.

Eight or nine pelicans showing all stages of the dive.

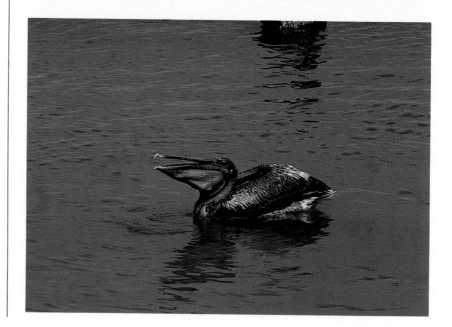

When the pelican feeds while floating on the surface, he ducks his head underwater into a school, coming up with water draining from his mandibles. When the water is out, the pelican swallows the fish headfirst, for fishes' backward-sloping fins would injure the bird's throat if swallowed tailfirst. Sometimes a sizable fish must be turned around in the pouch. In the lower picture a fish's outline can be seen in the pouch.

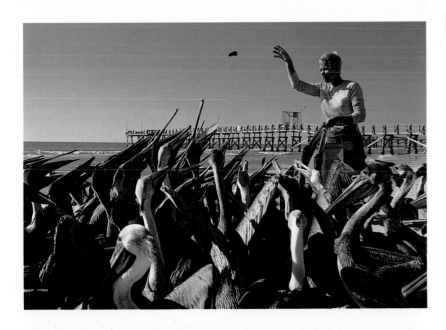

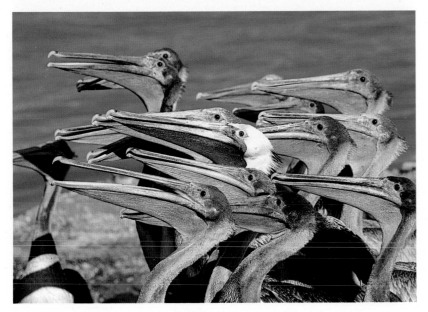

Mostly juvenile freeloaders at the Suncoast Seabird Sanctuary, St. Petersburg, Florida, eager to be fed. Sandi Middleton Smith, operations manager, takes several buckets of fish to distribute on the beach every day, feeding as many as three hundred birds at peak winter months. This helps to keep free-flyers away from the sanctuary pens, where they could harm nesting birds.

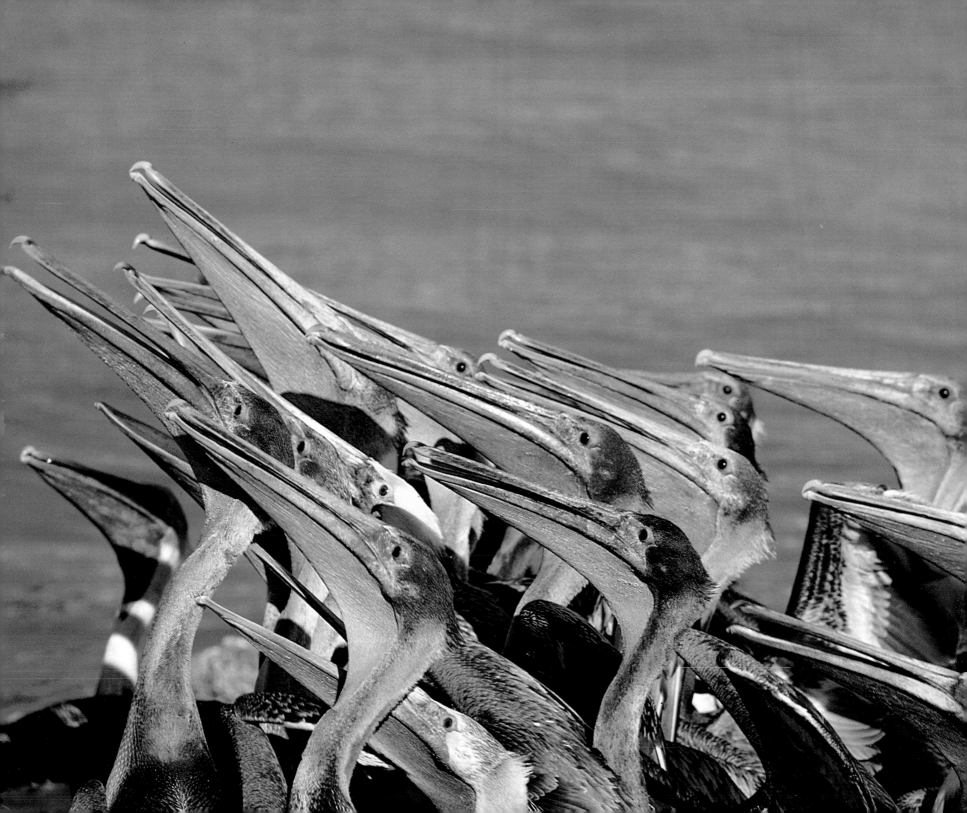

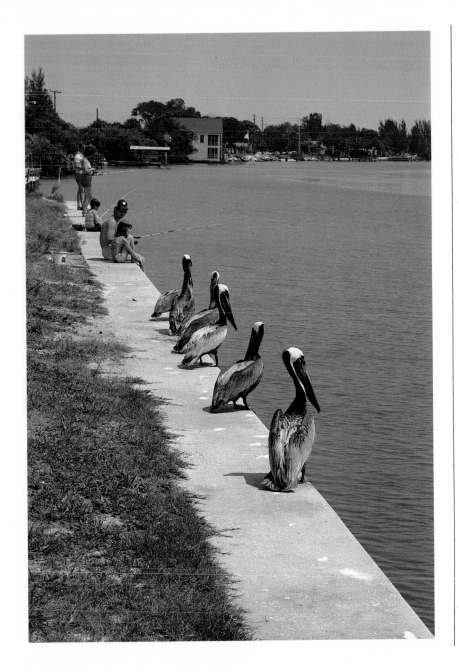

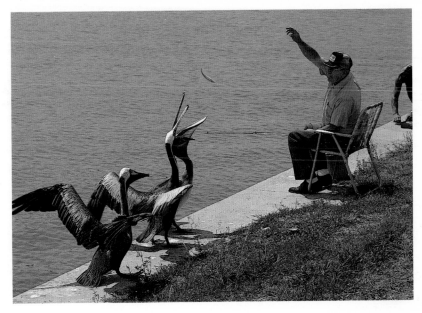

Two typical Florida scenes: Fishermen often pass on their small fish to their friends, the pelicans. Responding to the Save the Pelican program sponsored by the Suncoast Seabird Sanctuary, fishermen have become much more tidy with their lines and hooks that for years have caused thousands of pelican deaths along the Florida coasts.

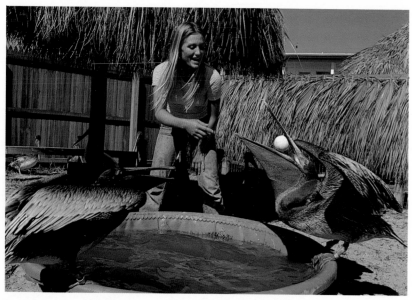

Above left: Dianna King, who has handled more pelicans than anyone in the world, plays ball with pelicans at the Suncoast Seabird Sanctuary. *Left*: Sandi Middleton Smith is trying to save her necklace. *Above*: Roger Tory Peterson and Ralph Heath with friend at the sanctuary.

Right: Stumpy, whose foot was amputated in 1974 at Suncoast after he was brought in by a sympathetic passerby who found the helpless pelican with his foot withered in a tangle of monofilament line. Nowadays, Stumpy's life is divided between the wild habitat and the safety of the sanctuary, where in 1983 he still returns for meals.

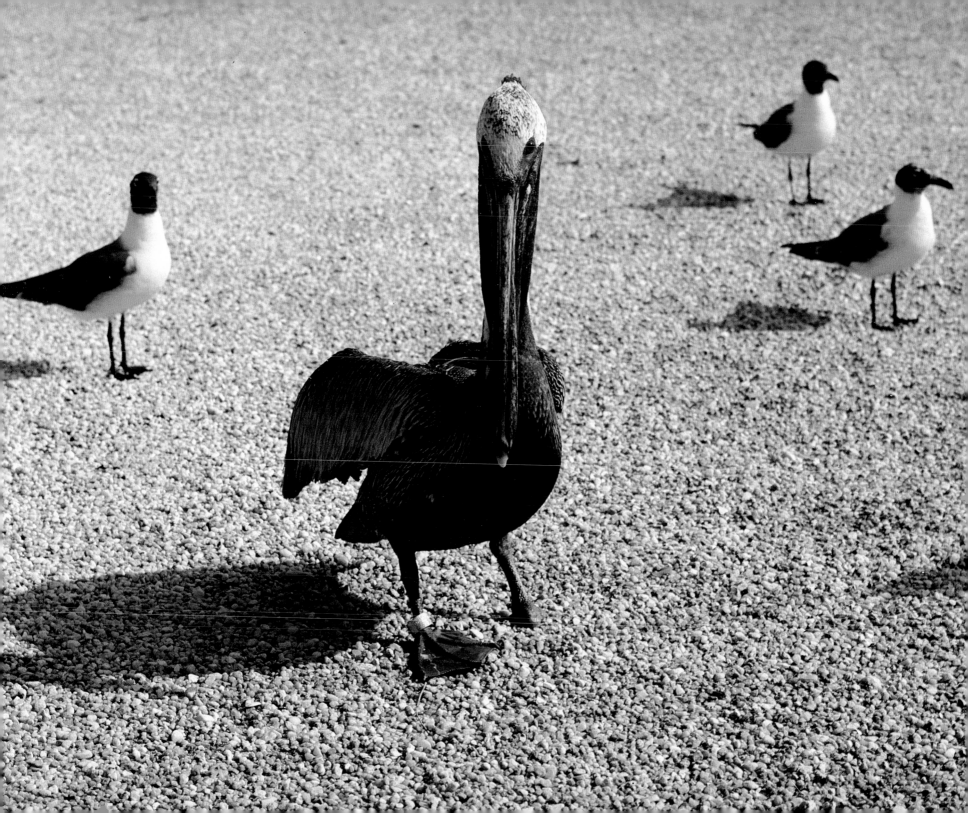

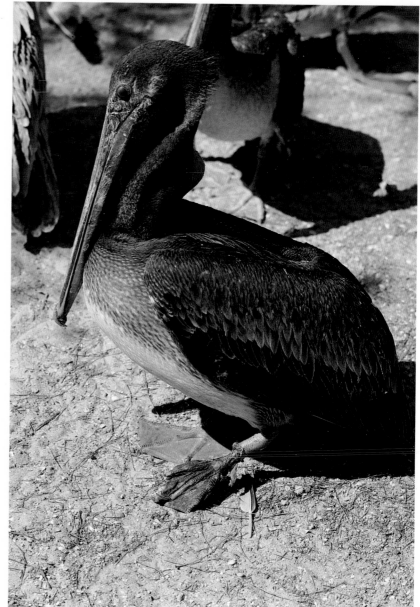

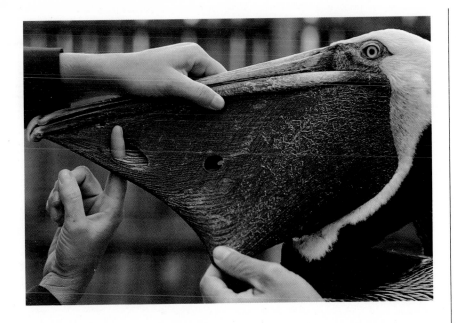

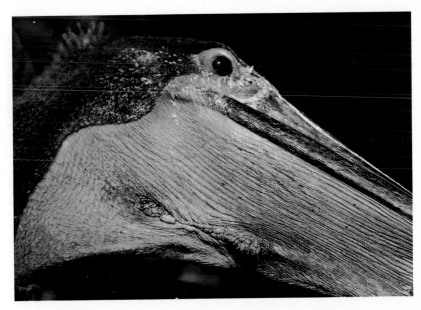

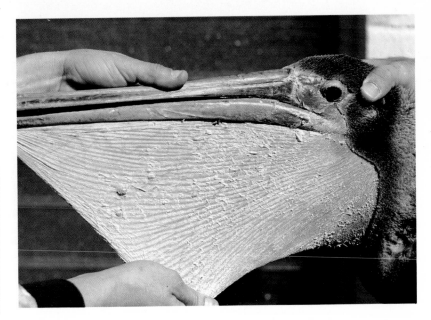

Far left: This young bird hangs dead from a mangrove tree, his body tangled in monofilament fishing line. Educational programs among fishermen in Florida have brought about a marked decrease in the enormous numbers of pelican deaths. This tragic sight is not as common as it was a decade ago.

Left: This immature brown pelican is luckier. Also caught in monofilament line, he was brought to the sanctuary. He will lose his left foot, but he will be able to fly again.

Above and Right: These are three different pelicans with pouch damage from fish-hooks. All were repaired at Suncoast Seabird Sanctuary at St. Petersburg. Such birds are sheltered and cared for at the sanctuary until they are able to return to the wild. Some are so disabled that they must spend their lives in captivity; but most of these captive birds nest and reproduce.

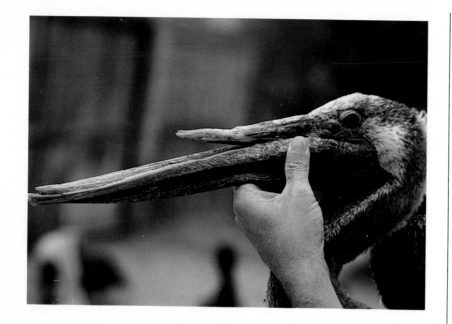

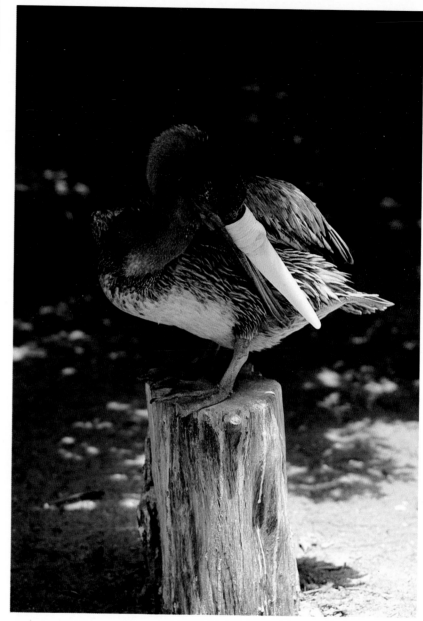

The upper mandible of the brown pelican above was destroyed by a fishhook. A plastic upper mandible has been fitted to the pelican on the right. Dr. Harry Albers, Suncoast veterinarian, has fashioned increasingly sophisticated artificial mandibles, the most recent from space-age plastics that can be glued in place. But birds bearing these repairs are not deemed capable of functioning in the wild by the workers at Suncoast.

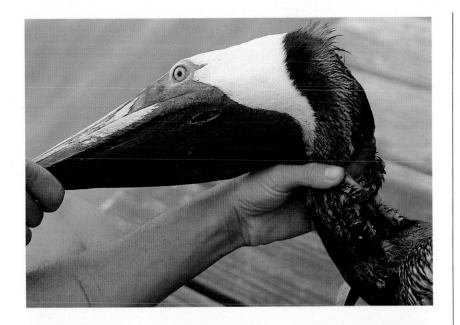

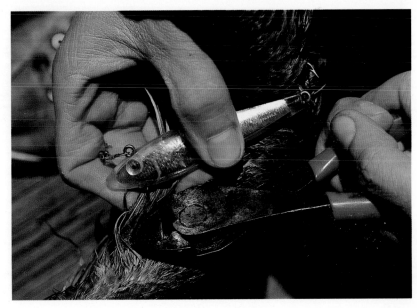

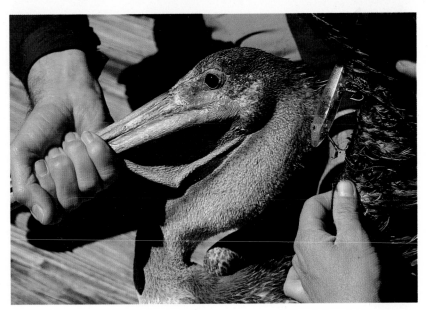

Eighteen stitches were required to repair fishhook injuries to the neck of this sexually mature pelican. Note the scar of an earlier injury below the eye. In the second and third views, Suncoast samaritans remove two sets of hooks and a lure from the neck of an immature bird. Barbs must be cut off before hooks can be backed out of a wound.

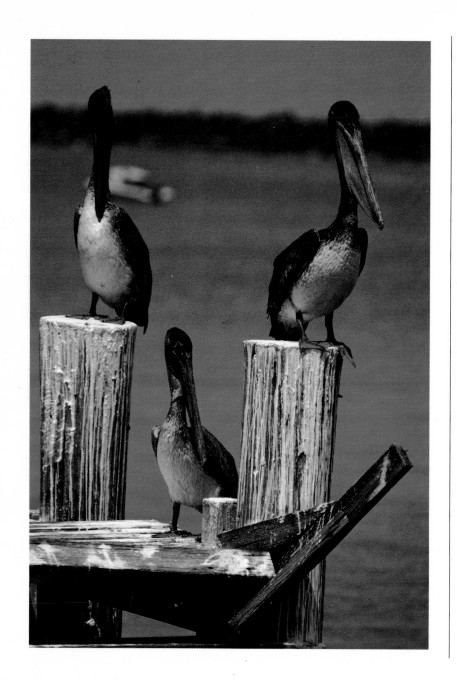

Left: Of these three pelicans sitting on a pier and pilings, the middle one will likely be immobilized by monofilament line and be found hanging dead or seriously damaged. A sinker lies on the pier, but the hook is in the neck of the one-year-old pelican. Most of the birds caught by fishhooks are immature.

Right: Dr. Harry Albers, Suncoast Seabird Sanctuary veterinarian, performs an autopsy on a dead pelican in the laboratory. *Far right above*: A detail showing typical roundworms in the intestine of the brown pelican. *Far right below*: A collection of lures and fishhooks, articles frequently removed from the pelicans by Dr. Albers at the sanctuary.

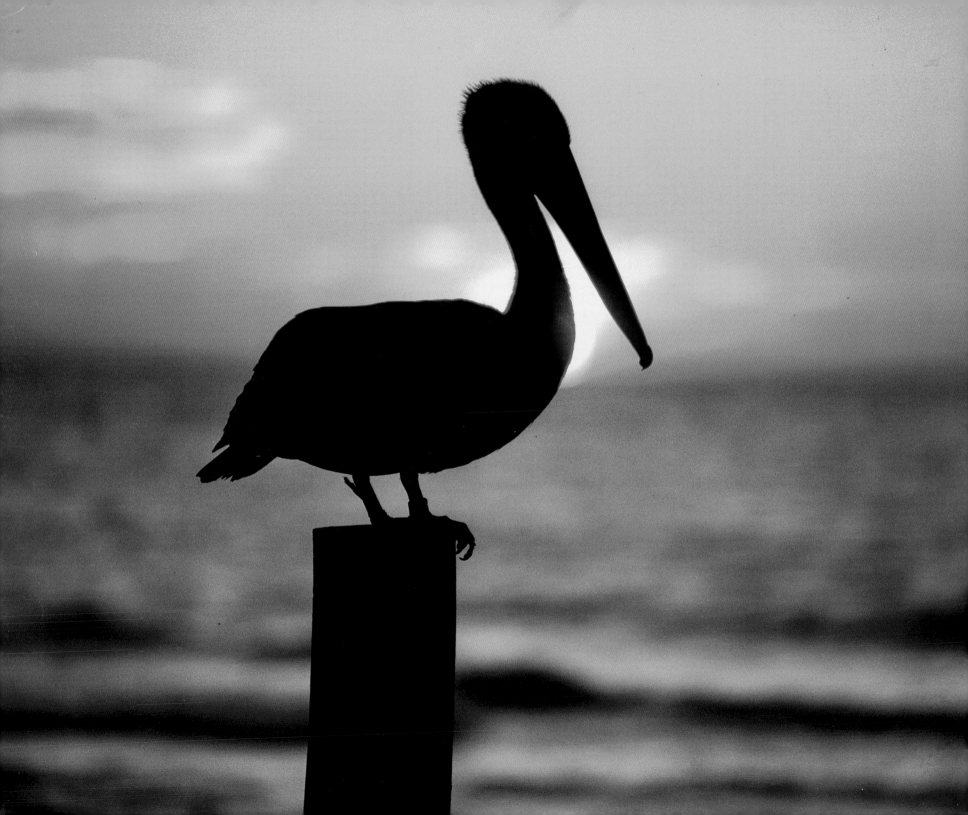

benign and claimed that to apply the theory to man is unfair because he is a vastly larger animal. Similarly, charges that DDT can cause neurological abnormality in man—as studied in several tests over periods of years among agricultural field workers who come into daily contact with pesticides—have been proved false. As a danger to man, then, the DDT threat has probably been much overrated. As a threat to wildlife, including the endangered brown pelican, the evidence is clearly damaging.

Because the California pelicans disappeared so rapidly, scientists could not monitor the decline (it was based on this experience that Florida launched its crash program of yearly censuses). They therefore had little information upon which to base scientific theories, although the little historical data at hand strongly suggested that causes such as disease and bad weather should be ruled out. Looking around the country, they found alarming clues that pointed to DDT; it seemed significant, for example, that a major decrease of the brown pelican population along the Texas and Louisiana coasts occurred after the year that eleven southern states began a program to control fire ants. The program was begun with little thought to controls; to eliminate this proliferating agricultural pest, huge areas were sprayed with heptachlor and dieldrin, both of which are chemically similar to DDT. Almost immediately, wildlife populations in and near the sprayed areas began to die off. In one particular Texas region, bird populations dropped as much as 97 percent. And in Florida, bird declines in the fall of 1968 occurred suspiciously close to areas where the fire ant program had been undertaken in that state.

As the later study of pelican colonies in Florida showed, brown pelicans tend to move about, often within a particular range. Since in the case of the California brown pelican this can include offshore islands of Mexico's Baja California, the disappearance of the bird from California waters might have been merely a seasonal shift southward. It was to update scientific data on the brown pelican that brought Dr. Risebrough and his colleagues to Anacapa in 1968.

Examining the crushed eggs, Dr. Risebrough wondered at first whether the damage might have been the work of gulls. Because western gulls nest in large numbers on Anacapa, pelicans have developed a defensive sentry system; unless they are frightened away by a larger animal, one parent bird remains on the nest constantly from incubation until hatched birds reach the fledgling stage. Parent pelicans are not fearful of an attack by the gulls, but if a human approaches—and on Anacapa, a yachtman's haven, this occurs frequently—they will leave their nests helplessly exposed to the small marauders.

Dr. Risebrough examined the eggs carefully and found that they did not appear to be pecked open. Instead, they were crushed as if by some weight they could not withstand. Since pelicans are generally heavy birds that incubate partly with their feet, nature has given the pelican egg the toughness to withstand such punishment. Only occasionally will an egg break, but on Anacapa, the destruction was widespread.

Dr. Risebrough discovered that in most cases the Anacapa eggshells seemed to be unusually thin, and laboratory examination showed them to be half the thickness of eggs collected on the same island prior to World War II. The interim period almost exactly paralleled the introduction and heaviest use of DDT and other pesticides in the United States, and Risebrough postulated that chlorinated hydrocarbons were probably involved in some way with the eggshell thinning and crushing. The pelican was not the first bird in which this phenomenon had occurred; other studies had indicated the same thinning effect of DDT on eggshells of the herring gull, white pelican, and double-crested cormorant. And scientists had established that shortly after World War II when DDT was gaining widespread acceptance several other species of birds had suffered population crashes in the United States and Europe.

The evidence mounted, and a clear picture began to emerge: chlorinated hydrocarbons applied to the coastal land had washed into the

sea in huge quantities. There, it first affected the tiny plankton, which in turn were ingested by fish. In fish-feeding pelicans, DDT accumulations affected the calcium carbonate; eggs formed, but the loss of calcium carbonate made their shells thinner than usual, and they were easily crushed under the incubating parent's weight. The parents were not discouraged, but eggs subsequently laid were as quickly broken. After several seasons of nesting failure, the Anacapa population had apparently migrated elsewhere or died off of old age.

In South Carolina, research by Lawrence J. Blus, biologist at the U.S. Fish and Wildlife Service's Patuxent Wildlife Research Center, determined that pelicans may be more susceptible to environmental pollutants than other waterbirds, and even other fish-feeding birds. The critical level of DDE in pelican eggs is 2.5 parts per million (ppm). Pelicans producing eggs with less than this level produce normal clutches of eggs, unless other, nonchemical factors intervene. But without exception, no young are produced from nests in which the eggs contain more than 2.5 ppm. Among Florida colonies, the DDE level never reached the 2.5 ppm concentration level. But in California, examination of the egg found by Risebrough on Anacapa indicated a level of 4.75 milligrams of DDE, the equivalent of 68 ppm of the total wet contents of the egg, or 950 ppm of the yolk lipid, which stores the lipid-soluble pesticides. Measured on Blus's yardstick, this meant that the Anacapa eggs were carrying more than 27 *times* the tolerable level of DDE.

An earlier possible pollution threat to the Anacapa brown pelican was the Santa Barbara oil spill of January–February, 1969, which dumped more than 500,000 gallons of crude oil over a 100-square-mile area of the Santa Barbara Channel, drifted east to blot the pristine resort beaches of Santa Barbara, and touched off a public outcry. It proved to be the turning point in America's historical indifference toward its environment, and the focal point for stringent federal and state pollution controls that soon followed.

Anacapa Island lies on the western edge of the Santa Barbara Channel. Since the spill occurred during the nesting season, it afforded a rare opportunity; the spill's effect was localized, and the status of pelican colonies at Anacapa and on Baja California islands, principally the Coronados nearest San Diego, could be compared. The effect of DDT would be about the same at both Anacapa and the Coronados, because they are approximately the same distance from coastal agricultural areas. If the Anacapa colony had suffered from something other than DDT, the recent oil spill would be a prime suspect.

To determine the geographic extent of the problem, Dr. Joseph Jehl, a zoologist with the San Diego Natural History Museum, accompanied by Dr. L. C. Binford of the California Academy of Science, began to visit several pelican colonies in northwestern Baja California in the spring of 1969. Their first stop was the Coronados.

Although hundreds of pelicans had once nested on the Coronados' North Island, only a few birds nested in 1963, and in subsequent years the colony was empty. Jehl and Binford were surprised to find more than 300 pairs attempting to nest in 1969 on South Island. The scientists' happy finding soured, however, when they examined the nests closely. It was the Anacapa story all over again; only 19 of 194 nests examined contained eggs, and bits of crushed egg and broken shell littered the ground under and around the nests.

"Many nests were freshly lined, and a few birds were trying once more to raise young," Jehl reported later. "They were unsuccessful. By early May, they had deserted the original colony; all the intact eggs had vanished. A few birds had moved to a new site, and about 20 pairs were still trying to nest. But it was obvious that they, too, would fail. Even these newly made nests contained broken and thin-shelled eggs. Thus, after only a few hours in the field, we had been able to show that the situation was not confined to Anacapa Island and therefore that oil pollution was not the causal factor. Analysis of Coronados eggs showed that they also contained high amounts of DDE, comparable to that found at Anacapa."

Still later investigation, by a team of scientists from the University of Southern California, absolved the Santa Barbara oil spill as even an indirect cause of the deterioration of nesting Anacapa birds.

California is one of the most intensely developed agricultural states of the nation. Because DDT and other pesticides had been used so extensively in this connection, Jehl hoped that the resulting damage to pelican colonies on Anacapa and the Coronados would be confined to those areas. "We thought it unlikely that there were remote colonies off the scarcely populated and little-farmed peninsula of Baja California," Jehl recalls. "But we were wrong."

San Martín Island, 150 miles south of the United States border at San Diego, has been a pelican nesting site at least since 1889 when ornithologist A. W. Anthony compiled one of the earliest records of how pelicans colonize and catch their fish during the nesting season. A mere speck of land, San Martín rises only fifty feet or so out of the sea at its highest point, the rim of a dormant volcano. In 1889 Anthony described the flurry of bird activity:

> Flocks of from five or six to twenty were constantly arriving from far out at sea, flying in one long line, each following directly in the track of the one next in front, and but just keeping above the water until within a few hundred yards of the island, when they rose gradually to the elevation of their nests. Toward night the flocks grew larger, as the birds that had been over to San Quentin Bay for the day's fishing began to arrive. These birds after fishing until sunset along the southern shore of the bay, gather in large flocks, and most of them fly directly up the bay, or almost at right angles with the course taken by those birds that fly directly toward the island.

Eighty years later, Jehl and Binford found pelican activity no less rewarding. "We found a large colony on the west end of the island," Jehl remembers, "but because of gull concentrations and the chance of egg predation we were unwilling to survey it thoroughly."

Unlike Anthony, however, the California scientists found no chicks in the San Martín colony. Although the pelicans were nesting, Jehl and Binford found evidence of egg breakage and thin, flaking shells under several nests. Subsequent laboratory testing of the shells indicated that their thickness was only 68 percent of pre–World War II eggs. (Revisiting San Martín several months later, the Californians counted far fewer birds.)

The last stop for Jehl and Binford was San Benito Island, farthest offshore of the Baja California Islands and 150 miles farther south of San Martín. Here the picture was a little brighter. Although nesting had just begun, the nests had full clutches of eggs and there was little breakage. Nevertheless, the shells were later found to be abnormally thin, much thinner than those sampled at the same location thirty years earlier.

On the east coast of Baja California, an associate of Jehl's, Monte Kirven, was investigating pelican colonies in the Gulf of California about the same time of the Jehl expedition on the opposite coast. Although he found some eggs with flaking shells, few eggs were broken. In May, when he returned, he was able to band only twenty-four young instead of the hundreds he had expected, and in many nests there were infertile eggs.

What conclusions could be drawn from the various nest-sampling expeditions so many miles apart, but involving the same group of brown pelicans? There seemed little doubt that chlorinated hydrocarbons were largely to blame for egg thinning and a subsequent and drastic decline in the number of new pelicans. Yet, what puzzled scientists then and now is why the same phenomenon occurs in island colonies very near farming areas where DDT was used heavily until its ban, and many hundreds of miles distant. In *A Voice for Wildlife*, for instance, Victor B. Scheffer, noted the decline of the San Martín population, then pointed out that the island is dozens of miles away from any agricultural region where DDT might conceivably have been used.

"One of our party in 1973 was an ornithologist who had visited San Martín Island twenty-five years earlier and had then counted 200

nesting pairs of pelicans," Sheffer notes in his book. "Now the nests were empty, long unused. He concluded that repeated disturbance by human visitors was the most likely reason for the disappearance of the birds. Not DDT, since San Martín is little touched by agricultural poisons."

To an extent, Joseph Jehl agrees with the theory. Now that an 800-mile highway extends the length of the once-inhospitable Baja California peninsula to thousands of recreation-seeking travelers, the offshore pelican breeding islands will be increasingly exposed to human impact. The road, of course, does not bring the automobile to San Martín, San Benito, and other islands, but it has opened the peninsula to hotels, fishing camps, and trailer parks that will make access to the islands by boat far easier.

Another major threat is the increasing horde of well-meaning visitors who descend on the Baja California coastal islands from the sea. Each year, via charter boat, thousands of Americans put ashore on the islands as part of an increasing number of tours advertised primarily as whale-watching expeditions. For millenia the magnificent California gray whale has chosen coastal lagoons and bays of western Baja California as a winter breeding ground; relying on an age-old instinct, gray whales begin their slow southward migration from the Arctic in the fall, and begin arriving in breeding areas such as Scammon's Lagoon, about halfway down the peninsula, in November and December. Armed with cameras, and, usually, a scientist guide, charter-boat passengers begin their own southward migration about the same time, and until recently, they followed the whales right into the shallow waters of Scammon's Lagoon itself.

In the early 1970s, the Mexican government, alarmed over reports that humans were unduly disturbing the gray whales in Scammon's at the worst possible time of the year (the whales were calving), declared the lagoon off-limits to all visitors except scientists. The edict was a sharp blow to operators of the charter boats, most of them sailing out of San Diego. They were forced to transport whale-watchers much farther south, to San Ignacio Lagoon. And because lagoon whale-watching was sometimes hampered by bad weather or timing miscalculations, the charter operators increased related activities, such as nature walks on San Benito, San Martín, and other islands.

"Unfortunately," Joseph Jehl notes, "the breeding season of gray whales and pelicans very closely coincide. It's the worst time of the year for the pelicans to be disturbed, and the heaviest time of the year in terms of human visitors." (In fairness to the tour operators, it must be noted that no guided tours are allowed near rookeries at nesting time. Individual passengers, however, often thoughtlessly intrude upon the birds.)

But human intrusion obviously would not cause eggshell thinning. That, it has now been well established, is the result of inadequate nutrition and the ingestion of fish containing the chlorinated hydrocarbons flowing from the land into the sea. Why then should California and Baja California colonies be affected almost equally?

There are two related possibilities, and only extensive scientific investigation may determine the degree of responsibility of each. One is suggested in a single sentence in Rachel Carson's *Silent Spring*, the best-selling book that warned of the dangers of pesticides years before it was publicly popular to do so. "It is not possible," Miss Carson wrote, "To add pesticides to water anywhere without threatening the purity of water everywhere." In other words, pesticides dumped into the sea near the Santa Barbara Channel may *not* affect only organisms in or near the channel alone; some of the runoff—minute particles, perhaps, but particles nevertheless, and particles with an amazingly long life—may drift with the tide and current to affect areas colonized by the pelican hundreds of miles away. Piecing the evidence together at Anacapa, the Coronados, and Baja California islands far to the south, substantially bears out the theory.

From 1960 to 1966 the United States alone produced nearly two billion pounds of "hard" chlorinated hydrocarbon pesticides. That

family includes aldrin, chloridane, dieldrin, heptachlor, and DDT itself. *Chemical Engineering* estimated in the late 1960s that "two thirds of all DDT ever produced still remains in existence and . . . most of it will eventually find its way into the sea." That statement requires little modification, even today.

The second factor that would likely draw Anacapa, Coronados, and San Martín pelicans into the same area of eggshell-thinning disaster would be migration. Although it is not very scientific to do so, let's set up a hypothetical situation. From the beginning, ornithologists have agreed that, unlike white pelicans, brown pelicans do not migrate. That means that they do not wander *far*, that they move about from year to year only within their range. In the case of the California brown pelican, geographically speaking, this is a very large range indeed, extending in the case of a few scattered birds from British Columbia on the north to larger populations on Anacapa and the Baja California islands to the south. In a straight line, that measures more than 1,400 miles.

Brown pelicans are persistent birds and caring parents. Over and over again they rebuild nests destroyed by wind and wave with a patience that would perhaps have taxed even Job. They do not give up when their eggs are destroyed by gull predators or crushed after pesticides have thinned the shells to the breaking point. Considering this, it is entirely possible that brown pelicans travel in greater numbers and over longer distances than ornithologists until recently more commonly believed. At least this may be true when the birds are relentlessly driven by instinct to find new colonization areas after established ones become unsuitable.

"Certainly, it is something we really don't know much about in California," San Diego's Dr. Jehl says. "While it is helpful for us to know the number of nesting pelican pairs each year on, say, North Island of the Coronados, the data mean very little if we don't have corresponding information on their migratory habits from year to year. Does a decline in a nesting population on San Martín coincide with a corresponding increase in the Coronados?"

Whatever the answer, the story of the California brown pelican ends on a far happier note than its beginning portended. Despite increasing impact by man, its population, like the Louisiana pelican, is once again on the increase. No one, not even the staunchest defenders of DDT, can deny that, except in isolated areas, the increase generally began *after* the use of DDT was prohibited by United States law in 1972. Although DDT was not the sole culprit for the California pelican's near extinction, it was, to a bird harassed by so many other dangers, in an ornithological way, the "straw that broke the pelican's back."

As late as spring, 1975, the California brown pelican, though still officially endangered, had scored one dramatic reproductive success after another except in the Gulf of California. Although figures are deceptive, because movement fluctuations from colony to colony are not precisely known, let's look at what has happened in just one of these colonies, the Coronado Islands, where this chapter began.

If plotted on a graph, a line indicating the pelican's success there would start with the year 1969, when not a single young pelican was known to have fledged on North Coronado Island. The following year, 1970, only three to five birds fledged. The number increased only slightly in 1971—to between 30 and 40—but zoomed to 200 in 1972. For unexplained reasons, the number dipped again, to a few dozen in 1973, then skyrocketed to an astonishing 1,200 in 1974.

Looking at such a graph, a computer specialist understandably might wonder aloud: Ah, but look—if DDT was not banned until 1972, why is it that the increase began two full years earlier, in 1970, after starting from zero in 1969? And why is it that the number of fledglings was reduced more than half the year *after* DDT was outlawed?

It's a good question, but unfortunately, the world of nature cannot be as neatly explained or tidily packaged as the precise, unerring, nonhuman, mathematical environment of the computer. Once again,

many other factors—most of them far from being fully understood—figure into the picture. More important is the second line in our imaginary graph denoting the incidence of eggshell thinning in California colonies. Despite the phenomenal increase in the Coronado colony in 1974, Dr. Jehl, conducting a study there as he does each year, found that 30 percent of all eggs there were abnormally thin and failed to hatch. On the other hand, the degree of eggshell thinning in areas farther removed from DDT residue—Baja California's San Benito Island, for instance—appears to be less year by year, if the number of successfully hatched chicks is a fair indicator.

"The outlawing of DDT by the federal government," according to the Audubon Society, "marked the turning point for the brown pelican. The marine ecosystem began to recover from its accumulated load of the long-lasting hydrocarbon." Although that may be an oversimplification, considering the maze of other hazards that threaten the pelican to a lesser degree, an appendix to the Audubon statement is well worth noting: "But documenting the recovery of the brown pelican has been complicated by the discovery of another harmful chemical substance, polychlorinated biphenyls. PCBs, because they are similar in structure to DDT and other chlorinated hydrocarbons, have been difficult to trace through the environment, and it is also difficult to separate their possible effects on the reproductive process of the birds from those of DDT and DDE."

Since 1976 the story of the West Coast brown pelican has been less optimistic than in the years after the recovery of pelican populations from pesticides. In 1977, for instance, a survey showed that the birds had bred less successfully on Mexico's Coronado Islands and in California's Anacapa than they had in 1976, both in terms of the total number of nests and of young produced per nest. According to Dr. Daniel W. Anderson of the University of California at Davis, it was not clear whether it could be explained away as just a bad year. On North Coronado, in 1977, for example, 260 nests produced 200 young birds, whereas in 1976, 473 nests produced 487 young. Anacapa nests produced only 10 percent as many young in 1977 as in the previous year.

Although many might agree with Dr. Anderson's statement that the downward trend "is no reason for panic," considering the overall comeback from DDT days, the logical question that remains is: *what went wrong*? Why another slump just when the pelican picture was steadily brightening? DDT could no longer be blamed; few, if any, crushed eggs were found in breeding areas in the 1977 censuses. "We found starved chicks, not broken eggshells," Dr. Anderson reported. "In some cases, pelicans were not attempting to build nests at all." His speculation was a sudden decline in the pelican's food supply.

Anderson and some other scientists believe the new problem can be traced directly to a decrease in anchovies, a principle staple of the pelican diet. "Since 1976," he suggests, "the anchovy population is way down in California waters, and the pelican behavior suggests that they are not breeding simply because they may not be finding enough food for their young."

The possible relationship between anchovy supply and pelican reproduction rates in the late 1970s led to a controversy over a California plan involving the state's anchovy fishery. California's Fish and Game Department in the Spring of 1978 touched off a furore by proposing a marked increase in the tonnage of anchovies that commercial fishermen could harvest for conversion into animal feed. Anderson, among others, opposed the policy; "Up to now," he contended, "the pelicans haven't been hurt by commercial fisheries. Our concern is about the future, if there is a large increase in harvesting."

Anderson noted that the brown pelican is not alone as an alleged victim of overfishing. Many other seabirds share Southern California's offshore islands and waters with the pelicans, and some of them are finding survival difficult. "The pelican gets all the attention because it is so well known and is on the endangered list," Anderson says. "But if you look around here, you will see that the pelican is only a part of the bird population."

In a single six-hour period in spring, 1978, aboard the vessel *Sea Ranger*, for instance, Anderson and colleagues counted 500 pelicans, 3 pelagic cormorants, 5,520 western gulls, 600 surf scooters, 750 brant cormorants, 5 double-breasted cormorants, 12 oyster catchers, and assorted grebes and plovers, in addition to many seals and sea lions, all near California's Channel Islands.

To the layman, that would seem to indicate that all is well with California's offshore birds, including the pelican. But Paul Kelly, a specialist with the Fish and Game Department, says that many birds in addition to the pelican are undergoing population declines. In the past, the Channel Islands served as home for bald eagles, peregrine falcons, and ospreys. Now, they are gone. Kelly fears that other species will follow.

Clearly it has been shown, then, that in California, as well as in other states that the brown pelican calls home, the widely debated and widely heralded prohibition of DDT does not necessarily guarantee the brown pelican's salvation. There are many other causes of the population fluctuation. Some are inevitable and unpreventable—weather, for one example—over which man has no control. It is the remainder of the influences—those over which he *does*—that could spell doom or survival not only for the pelican but for many other species of wildlife.

6

Man and the Pelican

Stumpy is a curious bird. Hobbling along on one leg due to an amputation, he's a perennial favorite of visitors to Ralph Heath's Suncoast Seabird Sanctuary, a living symbol of the American brown pelican's plight today . . . as well as of what man is at last trying to do to help the species.

A few years ago, a piece of monofilament fishing line snagged around Stumpy's right leg as he rested on the water of Tampa Bay. As he struggled to work the line free, it only drew tighter, cutting off the blood circulation. Finally, the limb withered under the bind, and Stumpy was helpless. A passerby took pity on him and telephoned Ralph Heath.

Under Heath's patient care, Stumpy survived the initial shock of being captured, even though the offending right leg eventually had to be amputated. Under intensive care, Stumpy soon managed to stand and hop about on the remaining good leg. Not many weeks later, he was flying again.

Nowadays, Stumpy lives a life divided between the wild, free habitat he once knew, and the safety of Heath's Suncoast Sanctuary, where he knows he has many human friends. He flies away from the sanctuary any time he wishes, and returns, usually in the late evening, to feed on the fish that sanctuary volunteers have provided and to spend the night with other pelicans there.

Hundreds, perhaps thousands, of other pelicans in Florida and elsewhere are not so fortunate as Stumpy, if *fortunate* is a word that can be used to describe a one-legged bird. Through intensive research and considerable exposure in the media, we now understand the pervasive threat of pesticides to the brown pelican and other

wildlife in the United States, and legislators have acted to prevent its spread. We know a little more than we did a few years ago about similar hazards to his existence: polluted sewage dumped into the nation's coastal areas and waterways, lethal industrial chemical runoff, creeping encroachment upon the pelican's habitat.

Extreme weather is a known danger. In 1978, for instance, fifteen brown pelicans were rescued by state wildlife workers near Yuma, Arizona, hundreds of miles away from their known saltwater habitat in Mexico's Gulf of California, often called the Sea of Cortez. Why the marine birds found themselves so far off their beaten track is not precisely known, but adverse weather conditions are a prime suspect. "Every summer," notes Bob Wright, special agent of the U.S. Fish and Wildlife Service, "we see this happen. There are storms far to the south of us, and these birds apparently get caught on the thermals—columns of heated, rising air—that blow them high in the air." By the time the winds abate, Wright speculates, "the pelicans are way inland, usually somewhere over Arizona. Looking for a place to land, they often mistake pavement or rocks for water."

Sadly, the fifteen birds rescued in 1978 were only a part of the wind-blown flock. "We found perhaps another fifty carcasses in the desert, some partly eaten by coyotes; these were young birds, only three to four months old, just learning to fly," Wright notes.

Unfortunately, far less publicity has been accorded another major hazard, one so commonplace that many do not even think of it as a hazard at all. It is the popular monofilament fishing line and barbed fishhook.

Like DDT, monofilament owes its genesis to World War II necessity. Before the war, sports fishermen relied almost exclusively on heavier, braided or woven fiber lines between hook and reel, because science had not yet come up with something combining extreme lightweight and strength. Many of the prewar fishing lines used silk or other natural fibers as their base, but when Pearl Harbor shut off supplies of many of these materials from Asia and other nations

where they were abundant, American chemists were quickly pressed into a search for a suitable replacement. Monofilament was the result, and it was used widely whenever strong, lightweight fibers were required. As fishermen began returning to their old familiar angling grounds after V-J Day, monofilament soared in popularity.

Broken down into two words, monofilament means a single (*mono*) threadlike part (*filament*). Its strength relies on a single strand of chemically produced line instead of many weaker lines woven together. Unlike the old silk or cotton lines, monofilament lasts for years and its strength is incredible; fish weighing hundreds of pounds have been landed with monofilament almost unbelievably small in diameter. Being very lightweight, it often drifts near the surface of the water for a long time before finally sinking to the bottom.

For the brown pelican, this miracle of the chemical laboratory has proved a hideous weapon. As a hypothetical example, a brown pelican soars high over Tampa Bay, scouting the waters below for bait fish to take back to his nesting colony not far away. Suddenly he brakes himself with his wings and plunges into the water. Though his sharp eyes have spotted the fish, they have failed to see the tangle of monofilament fishing line that some angler has cut from a backlashed reel and carelessly tossed away.

Entering the water, the pelican's legs get tangled in the almost invisible monofilament. As he struggles to free himself, the line grows tighter; other monofilament strands snare a wing. Helplessly trussed in this manner, the pelican feels his strength ebb. Unless he is found, he will certainly die of starvation or dehydration. In former days, before the war and before monofilament, this pelican perhaps had a chance. A nip of a sharp beak might have severed fiber line or, being heavier than monofilament, it probably would have sunk to the bottom after the fisherman's discard anyway. But for a water bird clutched in its tangle, monofilament is an almost certain deathtrap.

One estimate places the annual loss of Florida pelicans to fishhook and line injuries at more than 500, but the total count could conceiv-

ably be in the thousands. Suncoast Seabird Sanctuary alone treats from 300 to 500 pelicans a year—only those few birds rescued by good samaritans—and there is no way to estimate the unrescued that die back at the rookeries, dangling from a mangrove limb or so wrapped up by fishhooks and monofilament line that flight is impossible. Although the Suncoast Seabird Sanctuary is not the only organization rescuing and treating injured pelicans, it is the biggest by far, and there are many communities that have no comparable organization. Where no one is rescuing and rehabilitating pelicans in these coastal areas, hooked birds simply die a slow and painful death.

But fishing equipment is not the only cause of death. Along the shore of Tampa Bay, power lines seem almost invisible to pelicans in flight; striking them at any speed means serious injury at the least, and death is more common. Suspended by monofilament, barbed fish hooks are another danger; less easy to comprehend are the dozens of brown pelicans deliberately shot, smashed with clubs and oars, run down with speeding motorboats or otherwise given a death sentence by man's incredible cruelty each year.

While the National Audubon Society reports that the majority of bird mortalities can be traced to weather, inadequate food supply or natural predation, statistics at Ralph Heath's Suncoast Seabird Sanctuary indicate that accident frequency rates are rising alarmingly. The rate is especially on the increase in heavily developed urban areas like Tampa–St. Petersburg, which also happen to be areas preferred by the pelican and other water birds.

In the case of pelicans brought to the sanctuary, what Heath calls the "hook and line syndrome" is by far the major cause of death and injury. "More than 85 percent of injured pelicans brought here are damaged by hooks and lines. After rescuing and caring for several hundred birds with fishhook injuries, I learned that even the smallest injury must be considered of major importance and, in most cases, a serious detriment to the health and survival of the injured bird." At the University of South Florida, Dr. Ralph Schrieber's observations bore out the statistic. "Two fifths of all free-flying pelicans I've han-

dled," he says, "have had either angler's hooks or fishing lines attached to them somewhere, or have shown scars of such encounters. I regularly find pelicans hanging in the mangroves entangled by monofilament, either dead or dying of starvation."

Fishhooks are anathema for pelicans. Heath has treated pelicans with as many as nine hooks imbedded in their bodies, a quick invitation to infection and, unless the feathered victim is found and quickly treated, certain death.

"Sometimes hooks are attached to monofilament in the water, left by fishermen," he explains. "I've seen many other dead pelicans hanging on hooked trotline—fishing lines out on floats. Others fall victim to their own hunger. Sometimes, fish-eating birds try to steal a fisherman's bait and become hooked. Rather than fight a hooked pelican, some fishermen merely cut the line, leaving another death-trap in the water."

Ten percent of Heath's feathered patients—and that includes many species of water birds—have internal injuries of some kind. Six percent have suffered broken legs. Seven percent suffer from malnutrition or starvation. Broken necks, skulls, and backs account for another 3 percent. Once in awhile, the sanctuary birds are victims of nature's capricous whims; once, Heath treated a wounded cormorant whose underside had been ripped open by a shark, a very rare occurrence. Fortunately, the cormorant is a very strong bird, and this one apparently worked loose and escaped. "People on the beach saw him and brought him to us," Heath recalls. "He couldn't even stand or walk for the first few days. It wasn't long, though, before he gentled down and even let people touch him."

Such natural injuries and deaths, tragic as they may be, cannot be prevented, though Heath, perhaps more than any one person in the Florida area, has saved bird lives that otherwise might have been lost. Although equally tragic, loss to the hook and line syndrome is also understandable, since it is usually the result of just plain carelessness or ignorance of the danger.

What angers Ralph Heath most are attacks on birds by people. His

files spill over with reports of water birds treated for gunshot, arrow, and spear wounds. He says he has no way of knowing how many of the fractured bones and slashed bodies are the work of sadist freaks.

"There's one local monster who catches birds, ties their beaks together, then sets them free to starve. Another's trick is to wrap cherry bombs in bread, light the fuse, and toss them to sea gulls to catch. When one of those cherry bombs goes off inside, there's not much left of the victim."

In Heath's opinion, though, nothing is worse than motorboaters who use pelicans and other water birds as floating targets. "Some of these nuts roar around the bay at nearly sixty-five miles an hour. The birds, accustomed to man, seem to put up with the racket, especially if they're busy fishing. When a boat swerves toward them at close range at that speed, the birds simply can't take off fast enough."

It was on a December day in 1971 in St. Petersburg that Heath found his first injured water bird. Walking with his wife along Gulf Boulevard, he spotted a cormorant wobbling along with a broken wing. Other passersby had seen the bird, too, given it a glance of pity, and continued on. The Heaths consulted a veterinarian for treatment, then took the bird home for further care. Ralph Heath's life has not been the same since.

The cormorant, which Heath named Maynard, was the first of thousands of sick and injured birds that would be treated annually at the Suncoast Seabird Sanctuary. The majority were victims of encounters with man—his pollution, his monofilament line and fishhooks, his power lines, glass-windowed high-rise buildings, or his deliberate senseless cruelty. Treating so many thousands of sick and injured birds has provided personnel of the sanctuary with a unique opportunity to learn a great deal more than has ever been known about these creatures. Dianna King came to the sanctuary as a teenage volunteer more than ten years ago. She became a full-time employee shortly thereafter. Her responsibility is the captive brown pelicans. She has worked with more brown pelicans than anyone else in the world, and much of what we are learning about their behavior comes from her observations—all carefully noted. In response to the criticism that crippled or captive birds' behavior is modified by confinement, she points to the nesting wild birds in the Australian pine trees above three of her pelican pens. These are wild free-flyers that started nesting above the confined birds in 1978. They chose this spot because of its proximity to a reliable source of food—Suncoast Seabird Sanctuary—and because they are colonial nesters and were provided a viable nucleus by the nesting crippled birds. Dianna has not been able to find any significant difference between the behavior of the wild free-flyers and her crippled charges.

Since 1972, when the sanctuary was incorporated as a nonprofit charitable institution, Dr. Harry Albers of St. Petersburg has been its official veterinarian. He has been a director of the organization almost as long. His responsibilities include supervising the treatment of sick and injured birds, the training of the paramedics who work full time at the sanctuary, and personally handling all the problem cases.

On a typical day Dr. Albers also tends to several dozen household pets that arrive at his clinic in Volkswagen and Cadillac. By six P.M. or later he usually reaches the point where his patient-load thins down, and it is then that Dianna King will arrive from the sanctuary with a cage or two of problem birds. She may have a pelican with a wing compound fracture too difficult for the paramedics to set, or a pelican with a mutilated upper mandible so horribly lacerated by a fishhook that it must be amputated and the bird fitted with a plastic prosthetic device. Over the years, Dr. Albers has developed several artificial bills. The earlier ones were crude devices that would never do in the wild, so sanctuary patients without upper mandibles were permanently pinioned and the rough bills fitted so they could be fed. More recently rather sophisticated devices are fashioned of space-age plastics and glued in place. If the glue holds, the birds can conceivably be allowed to return to the wild. This method was employed in southern California in 1982 when vandals mutilated over a dozen brown pelicans by cutting off their upper bills. So far no Suncoast

bird with an artificial bill has been released; Dianna King feels that it is too risky.

Dr. Albers has had no library of medical text books to lean on in developing treatments for sick and injured wild birds, and few other veterinarians are working on wild birds. Although there is a wealth of information on the treatment of domesticated birds, no one assumes that a pelican's medical problems in any way parallel a chicken's. Nevertheless, more than 50 percent of Albers' sick and crippled birds recover, with most returning to the wild. The free contribution of his time to wild birds has enabled the Suncoast Seabird Sanctuary to flourish.

When asked why he devotes so much time to Suncoast, Dr. Albers' stock reply is that he would rather do this than spend his time playing second-rate golf.

As the Suncoast Seabird Sanctuary has evolved from a backyard treatment center (it still is located in the Heaths' backyard, but now the facility takes up all adjoining undeveloped property) to a major operation involving several full-time employees and a like number of volunteers, Ralph Heath no longer gets involved with the everyday work of the sanctuary. He spends his time getting the message across to the public, through television interviews and other media publicity, launching one drive—usually for funds—after another.

Perhaps his most significant contribution to the welfare of the brown pelican has been in the area of education. For years he has lectured on the care of injured birds. The sanctuary has produced a succession of publications on first aid for injured or sick brown pelicans, as well as other avian species. The message has been slow in catching on, but it *is* catching on, and nowhere is this more evident than in the Tampa Bay area. A half dozen years ago a visit to one of the pelican rookeries was a depressing experience, but that is no longer the case. People have become aware of the damage they were doing; fishermen are becoming tidier; fewer pelicans are being hooked; and birds that are hooked are most often cared for either by the fisherman or a sympathetic bait shop operator. Whereas bait operators used to call the Suncoast Seabird Sanctuary to have someone come to the aid of a hooked bird, most of them have learned how to capture a pelican, how to remove a hook, and how to dress a wound. Only the seriously injured are sent to the sanctuary. Joe the Bait Lady who runs a bait shop at Clearwater, a suburb of St. Petersburg, reports that in the average week she captures and removes hooks or lines from several birds. Joe solicits contributions so that she can feed hungry pelicans during cold winters, when they have trouble catching enough fish to stay alive. She points out that a well-fed pelican is much less likely to try to steal a fisherman's catch and get hooked in the process.

A recent grant from Exxon provided the sanctuary with funds to produce a hard-hitting television message cautioning fishermen to use good judgment when fishing near pelicans, to be doubly tidy with their gear and monofilament line, and instructing them in the capture and treatment of hooked birds. The message is regularly aired as a public service by stations in the Tampa Bay area and in other coastal areas of Florida. It is available to any station in a region where the brown pelican is found.

Some coastal residents consider the activities of the Suncoast Seabird Sanctuary to be counterproductive. They are distressed by the appearance of maimed brown pelicans; they would simply put the birds to sleep in a humane fashion. Dianna King gets fighting mad at this suggestion. Her cripples are her friends, and while they may not look too elegant with a missing wing, a missing foot, or a plastic upper mandible, they live reasonably normal lives. They mate and they produce healthy young; more than 160 have fledged since pelicans started nesting at the sanctuary several years ago. Furthermore, they provide a unique laboratory for studying pelican behavior.

Most of the brown pelican pairs at the sanctuary are monogamous, although wife- and husband-swapping have been noted a time or two. It was once thought that only birds with brown bellies and white

heads were sexually mature and produced young, but birds at the sanctuary frequently nest in their second year. This pattern has recently been noted in some wild birds. Sanctuary birds nest two times and sometimes a third time in a single year. The first nesting effort frequently takes place in October or November, then again in March or April, and finally in June or July.

Sanctuary birds frequently engage in play activities with their keepers. Dianna King has for years amused visitors at the sanctuary by playing catch with several pelicans, using a small soft rubber ball. While their catching skills do not compare to a Pete Rose, they do pretty well considering that they are using their mouths. They seldom throw the ball more than four or five feet, just far enough to make a game of it that they and the spectators enjoy together.

Another by-product of the Suncoast Seabird Sanctuary's educational campaign has been an increased public awareness in the Tampa Bay area of the unfortunate plight of the brown pelican during extremely cold winters. When the water temperature drops below 68°F, the bait fish on which the pelicans feed move deeper than the birds can dive. Furthermore, the cold weather is usually associated with high winds and turbulent water. The pelicans become extremely malnourished, especially the young inexperienced birds, and so weakened that many do not survive the winter. In 1968 Sue Richardson, a Shore Acres resident, started collecting money to purchase food for hungry brown pelicans. Administration of the fund was subsequently taken over by the St. Petersburg city manager's office. In 1982 the city council, recognizing the inadequacy of the funds being donated, voted to use public monies to support the Feed the Pelican Fund. Several thousand dollars are allotted to feed a total of about six hundred birds a day at eight feeding stations. Twenty-five volunteers take care of the daily feedings.

The Suncoast Seabird Sanctuary also gets its share of hungry free-flying birds during the winter months. To keep the free-flying birds out of the pens Sandi Middleton Smith, operations manager at the sanctuary, with two or three volunteers, will usually take several buckets of fish to distribute on the beach area below the pens. This tends to keep many of the freeloaders out of the pens where they could do physical harm to the nesting birds. During the peak winter months as many as three hundred free-flying birds are fed daily. The cost of fish is staggering, and the food bill, to quote Sandi, "goes through the roof."

Dr. Harry Albers started a program in 1979 that is designed to keep many of the Tampa Bay brown pelicans healthier in the cold winter months. This is done by worming free-flying birds that come to the Suncoast Seabird Sanctuary for a free meal, or on occasion Dr. Albers takes an assistant or two to one of the island rookeries where they will try to treat as many of the young birds as possible. The operation is reasonably simple. A worm pill is simply stuffed into the mouth of a small dead fish and then tossed to a brown pelican. Dr. Albers uses a tested medication that can be administered in the necessary dosages without harming the birds. He feels that this treatment may result in significant reductions in winter mortality among the young brown pelicans.

It would appear that Florida's brown pelican population has a reasonably bright future. There is a public awareness of the plight of the bird. Efforts are being made to reduce the carnage caused by fishhooks, monofilament line, and vandalism. During cold winters, at least in the St. Petersburg area, they are being provided with minimal amounts of food. Their nesting areas are being protected, and barring an unforeseen natural disaster, we should expect an increase in sexually matured birds.

In 1914 a bird died in the Cincinnati Zoo. It was a passenger pigeon, a very special passenger pigeon; with its death its species vanished from the earth. When word of the death spread, a shock wave rippled far beyond the borders of Cincinnati, for not many years before, passenger pigeons had blackened the skies of the Midwest.

The Carolina parakeet passed from nature's registry in 1904, as did the greak auk in 1803, slaughtered to extinction for bait and by sealers for their oil. Hunters shot the sweet-tasting Labrador duck until, one day in the 1870s, it, too, disappeared.

For a while, it appeared as if the brown pelican might join the list of America's vanishing creatures. Briefly in some areas, it did, only to make a surprising comeback. But though happy that return has been, it is a tenuous one. The pressures on this species are enormous. Increasingly, we have routed it from its home, polluted it with our poisons, legislated away its food supply, maimed and killed it with devices created to enhance our recreational enjoyment.

But it is not the brown pelican alone that is endangered; in a sense, it is all wildlife for which, like the miner's canary, the pelican is a living early warning system of danger. If we heed the pelican's warning, the pelican may survive. If we do not, the shores and coastal skies of our continent may be suddenly emptier. And man, too, may be in peril.

Index